Wild Animals
Adult Coloring Book

Copyright © 2018 Eden Colors. All Rights Reserved.

Our coloring pages are created by a team of independent artists and exclusively licensed to Eden Colors. No part of this publication may be copied, reproduced or transmitted in any form, by any means, electronic or otherwise, without prior consent from the copyright owner and publisher of this book.

Bonus – Download

Sign up to the **edencolors.com/newsletter** and download 20 Mandala coloring pages for free!

As a subscriber, be the first to know about new publications & get access to exclusive discounts and free gifts.

Visit Us Online

EdenColors.com – info@edencolors.com

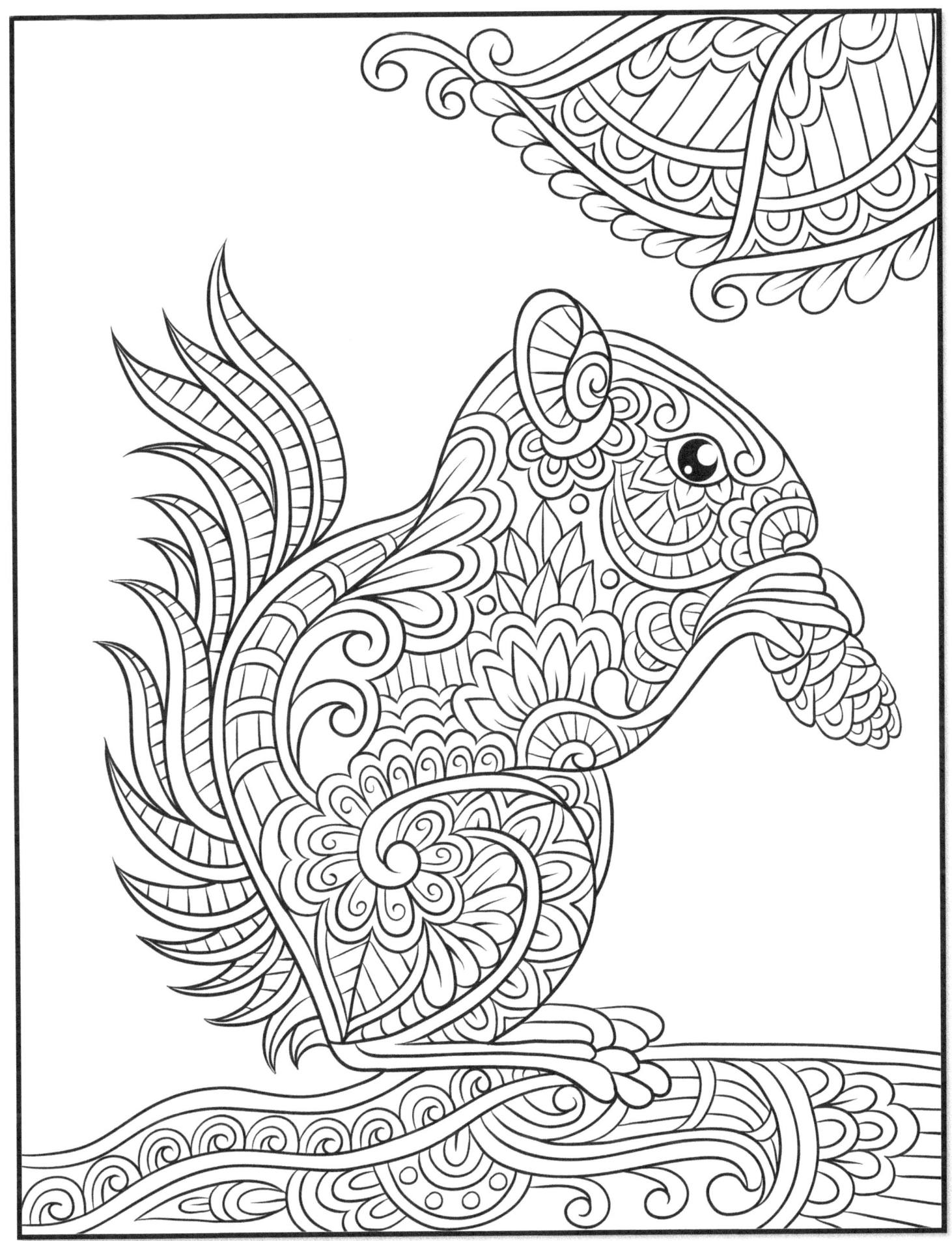

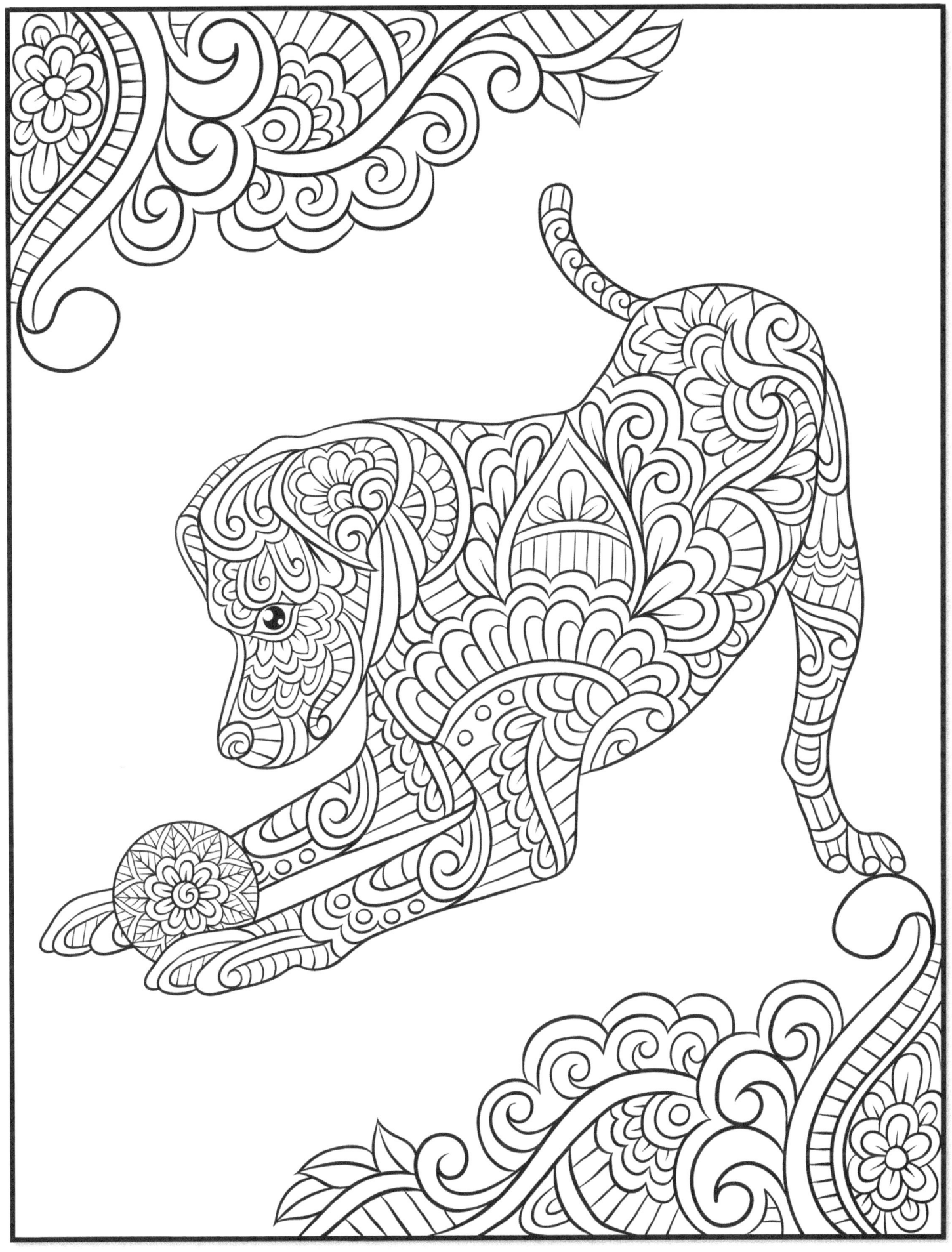

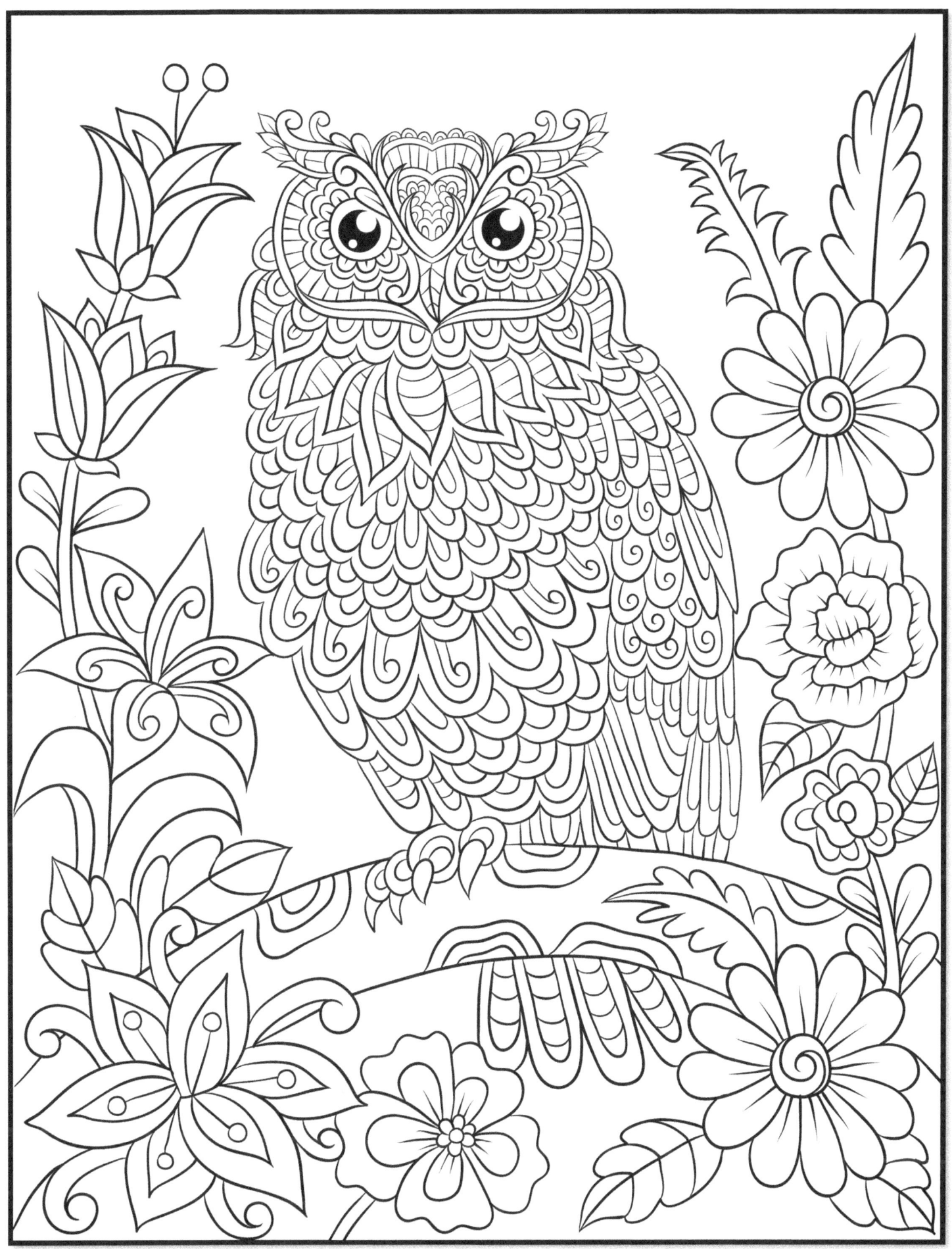

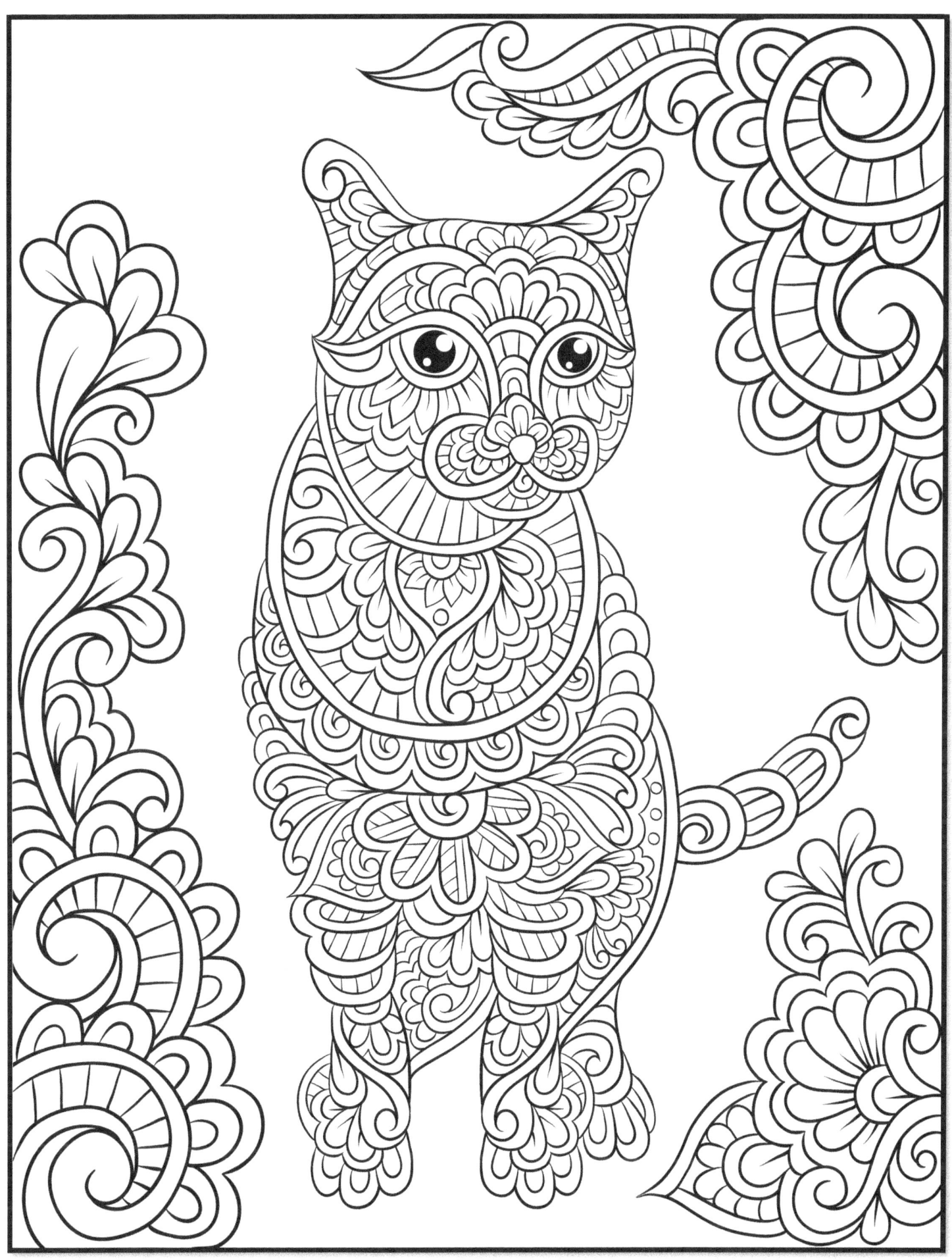

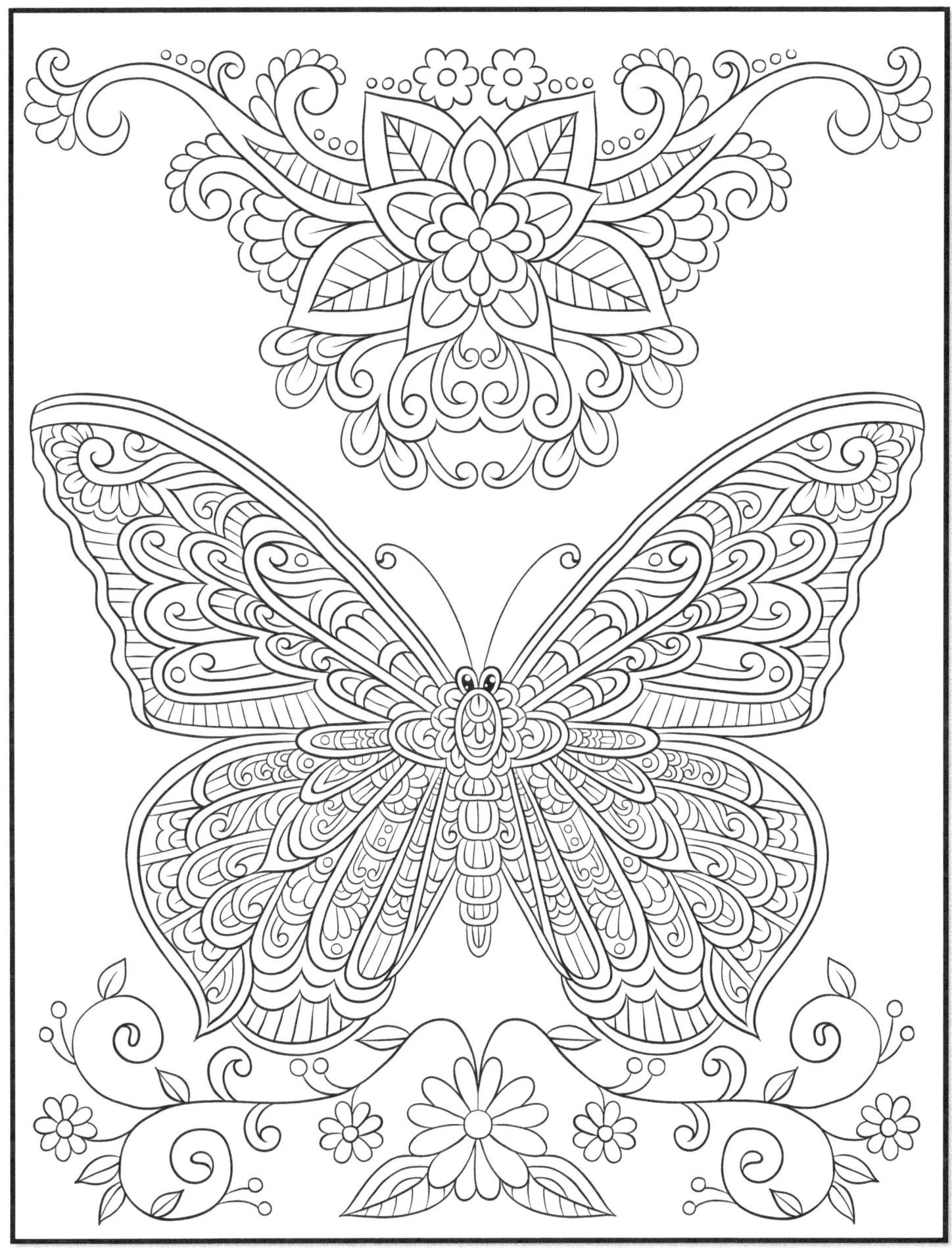

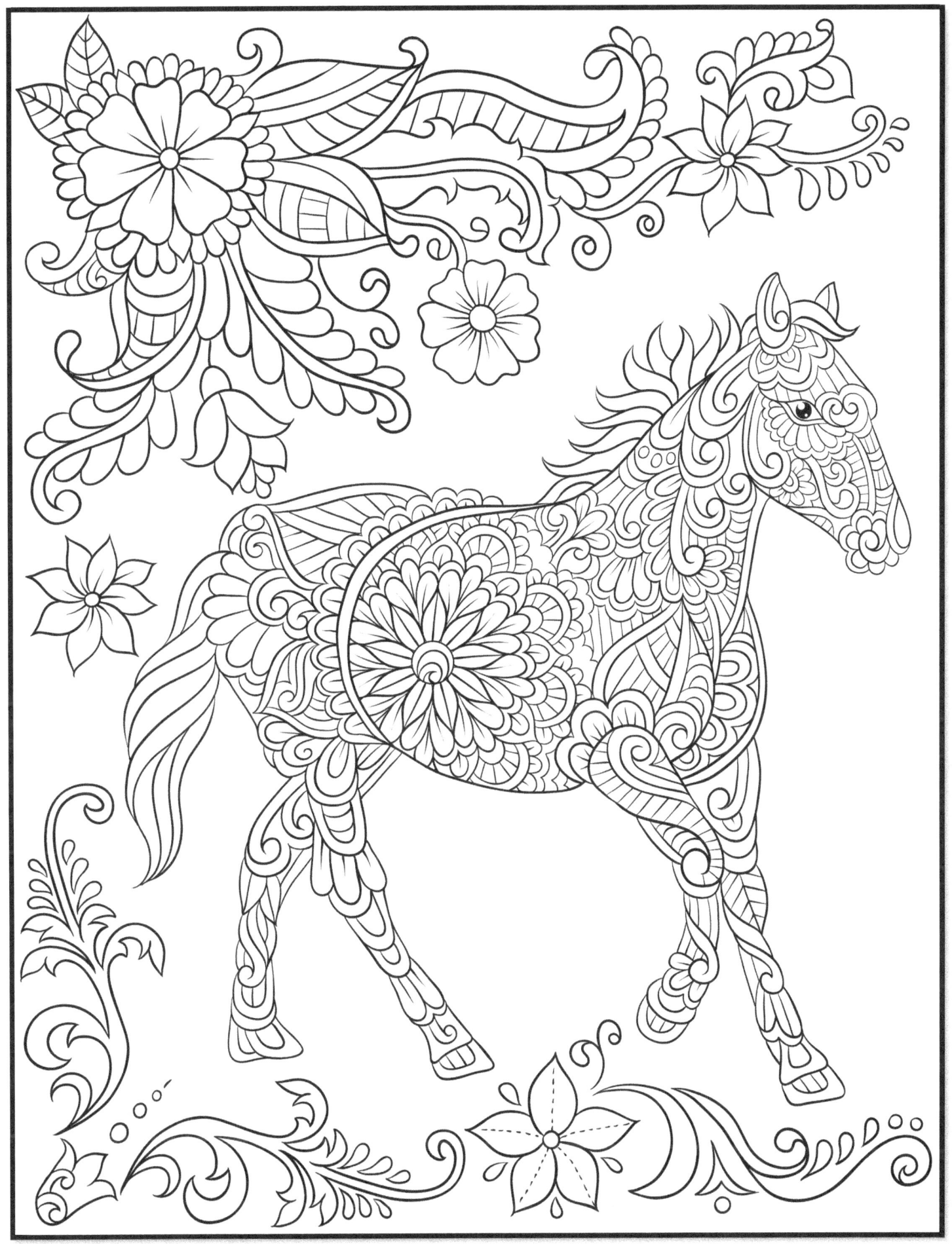

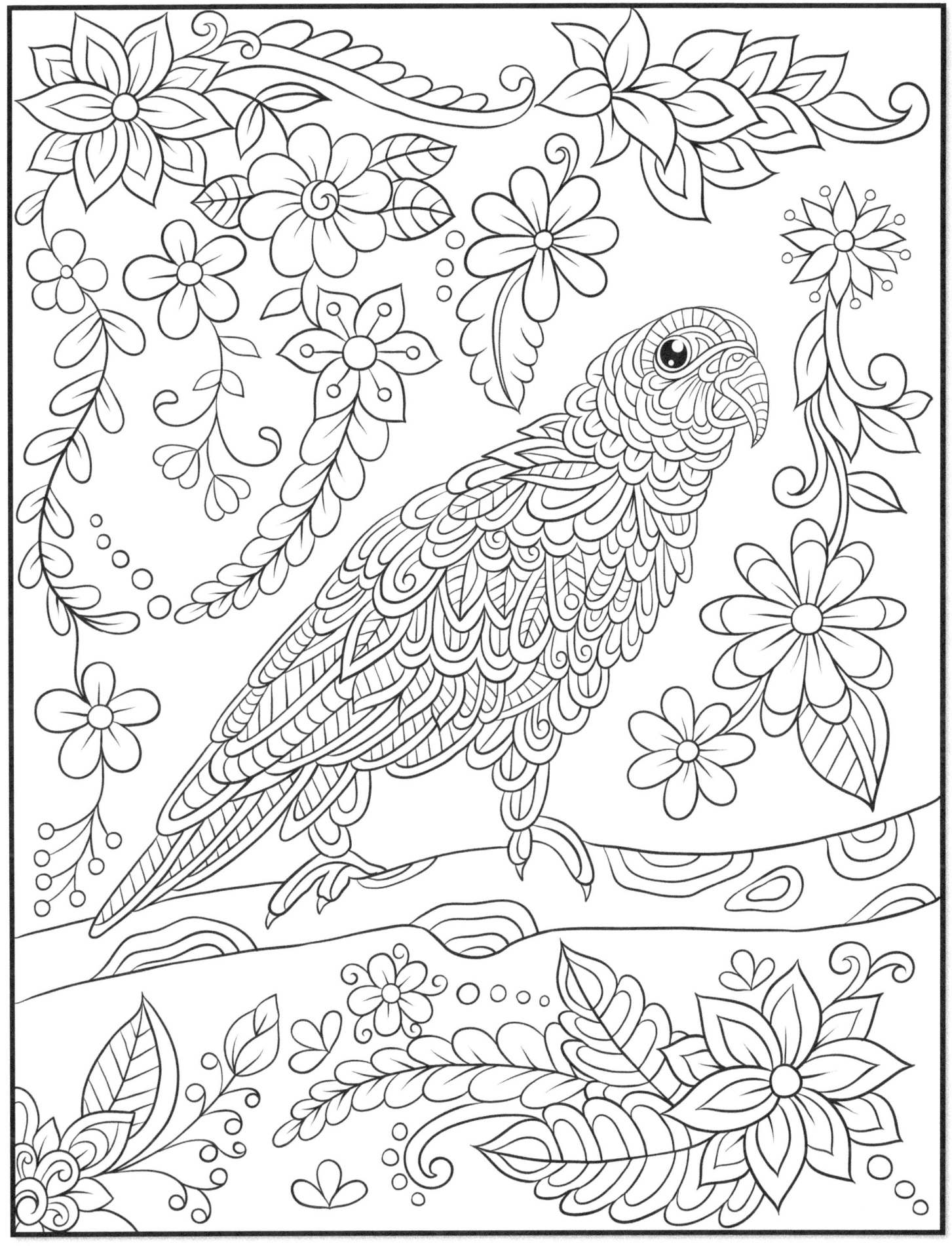

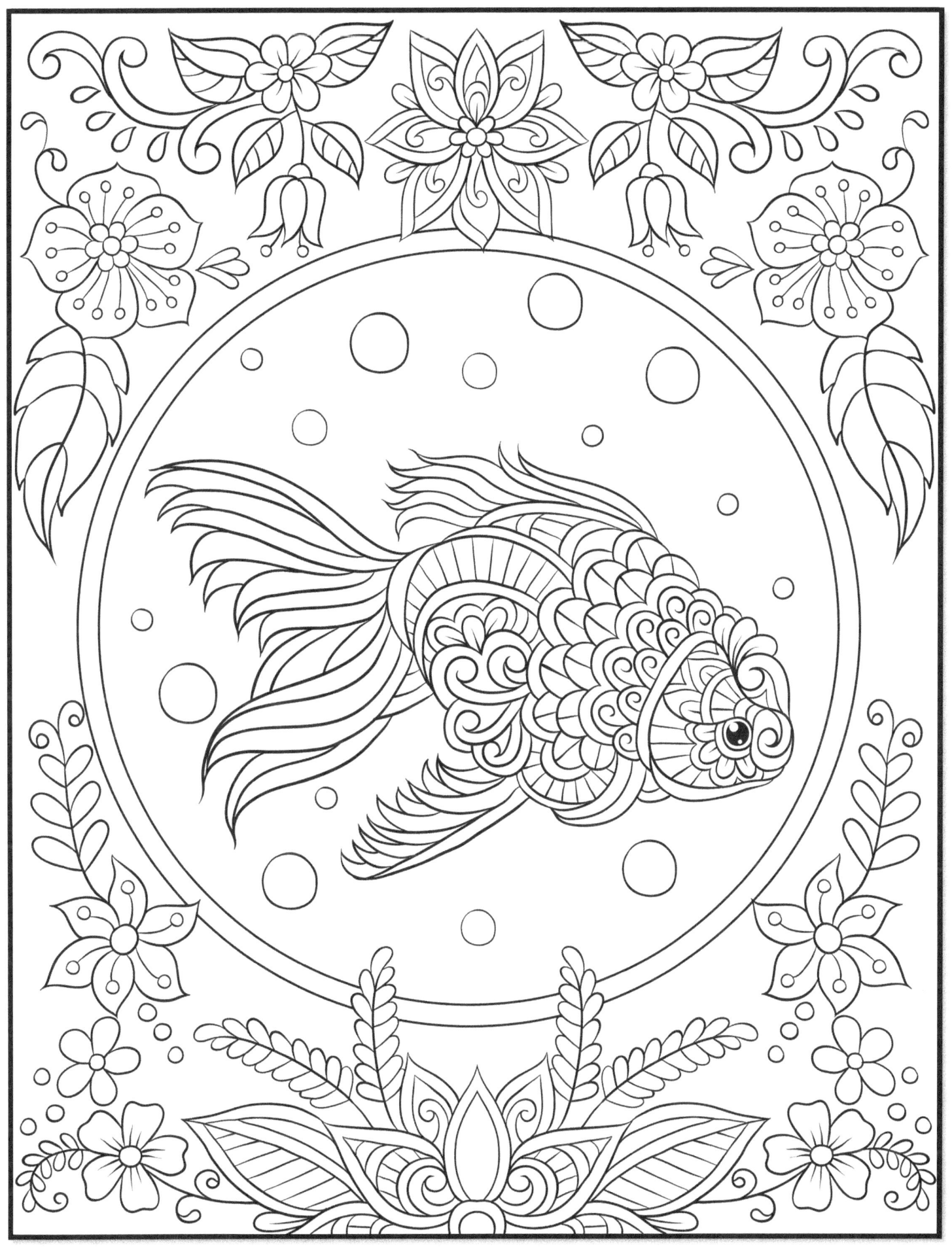

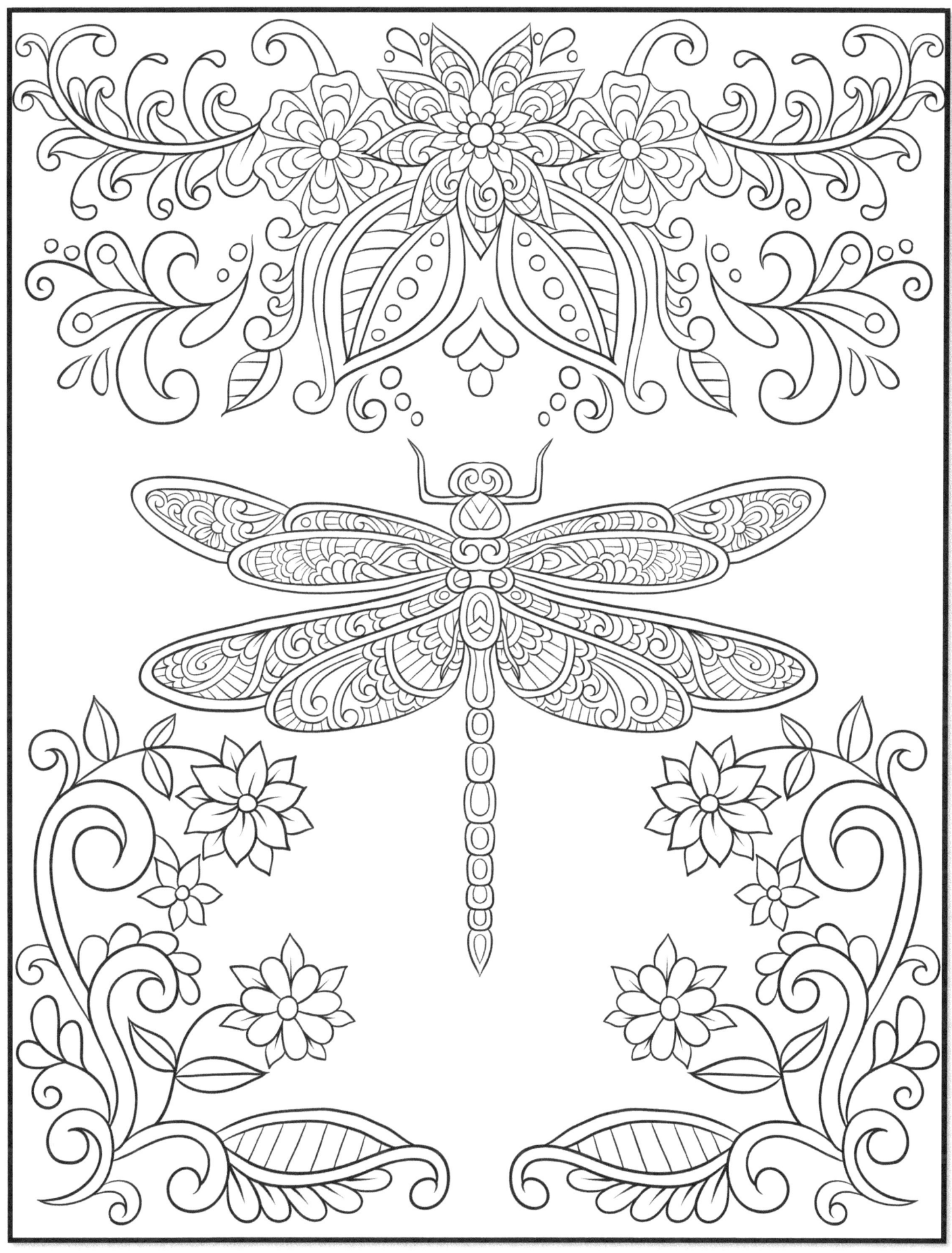

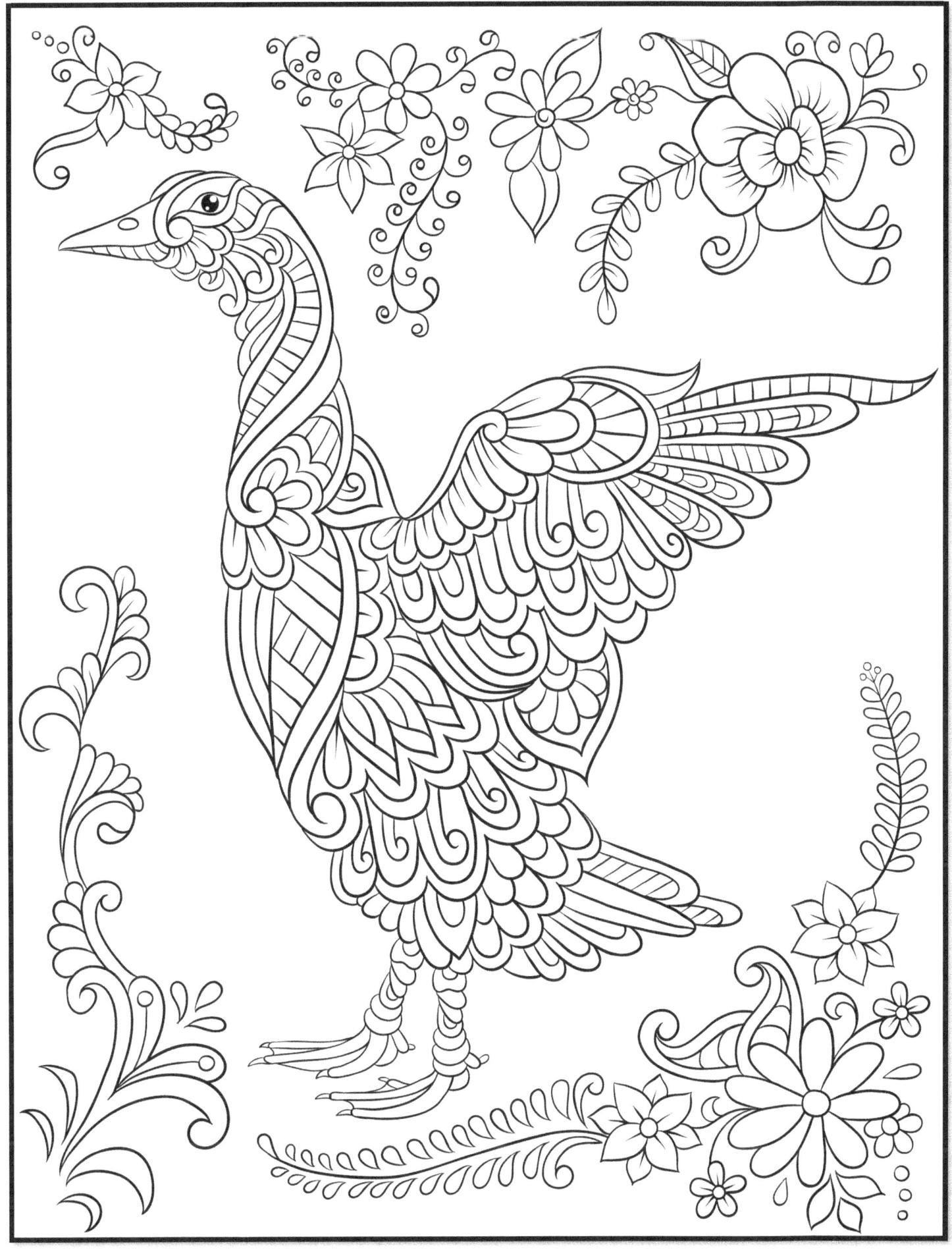

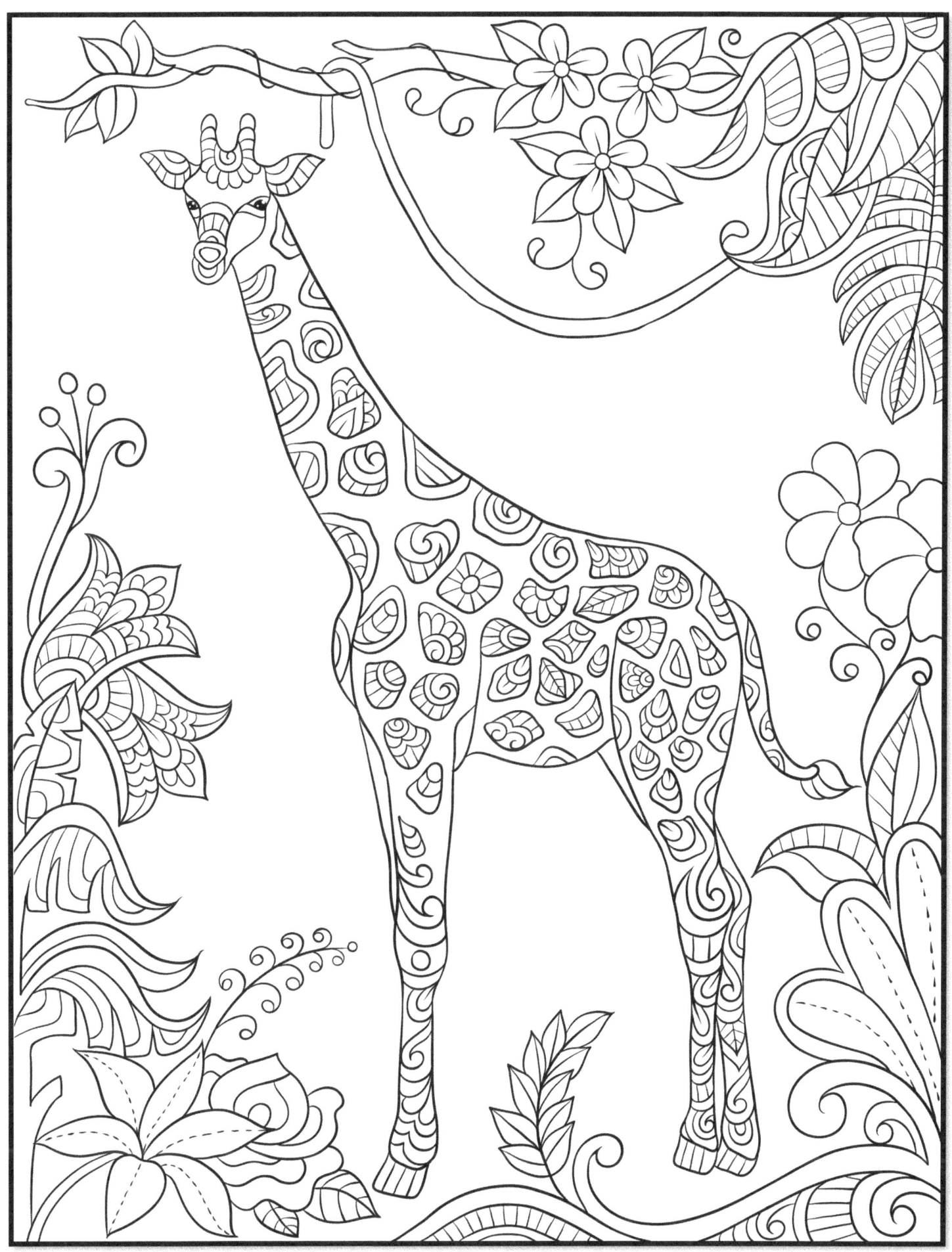

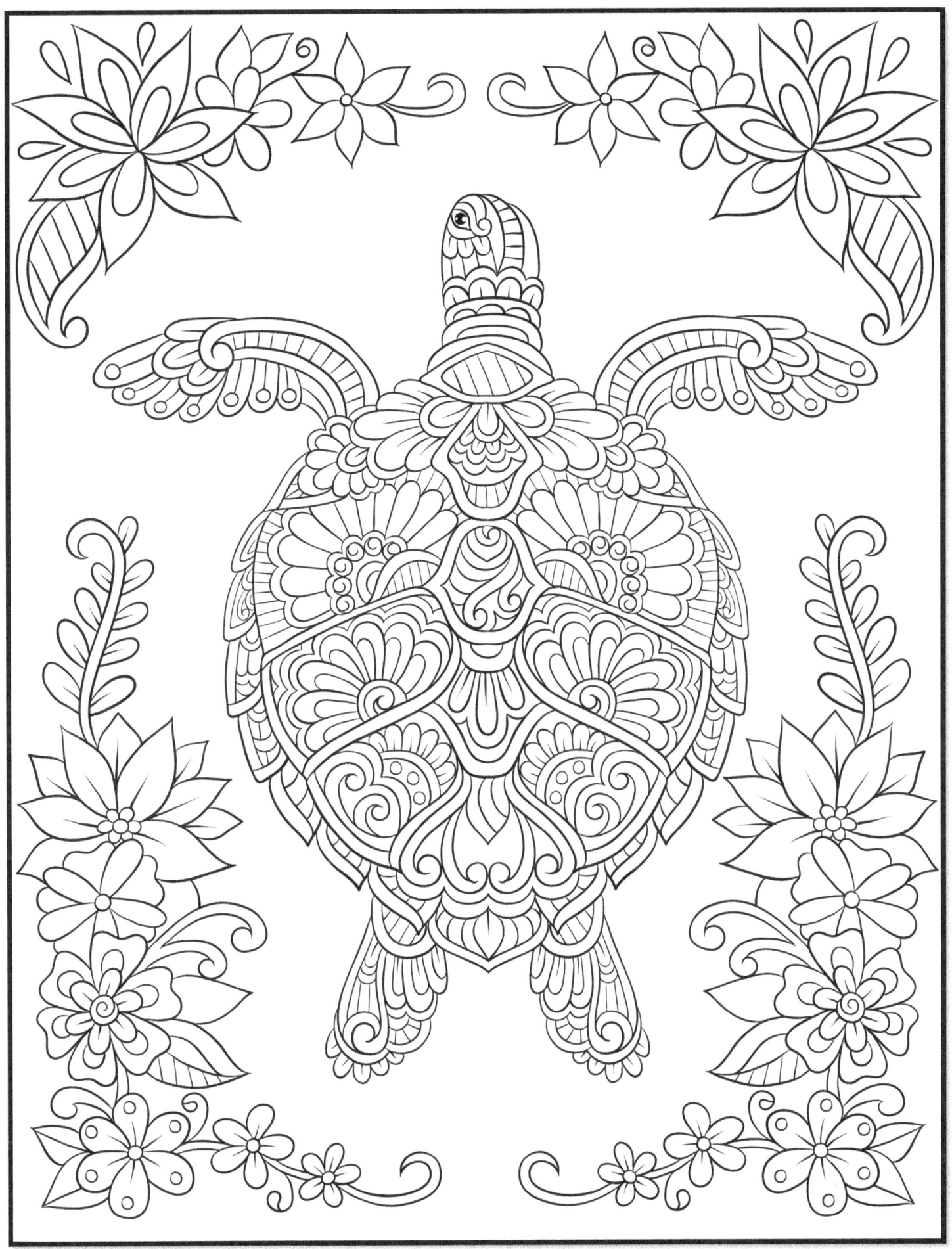

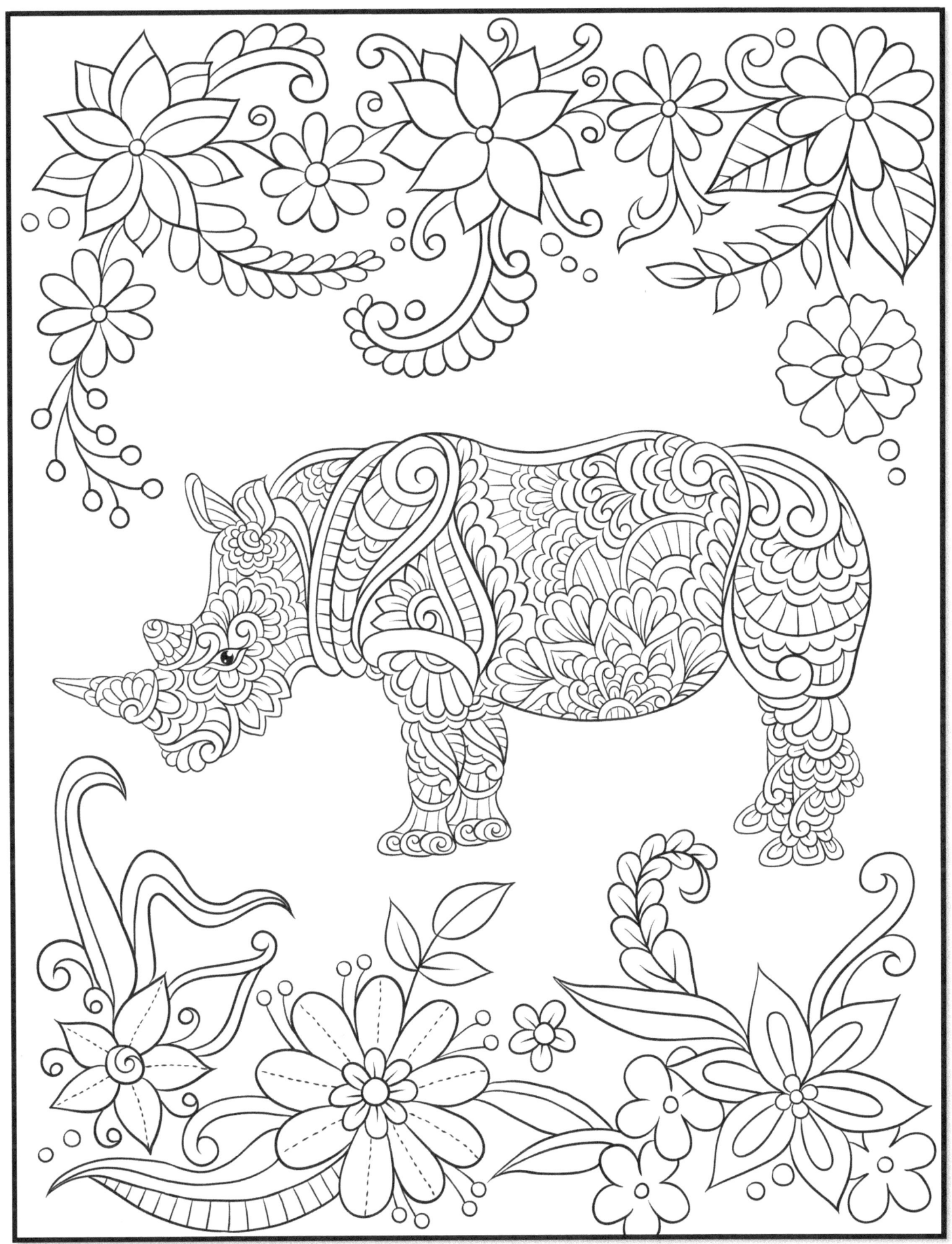

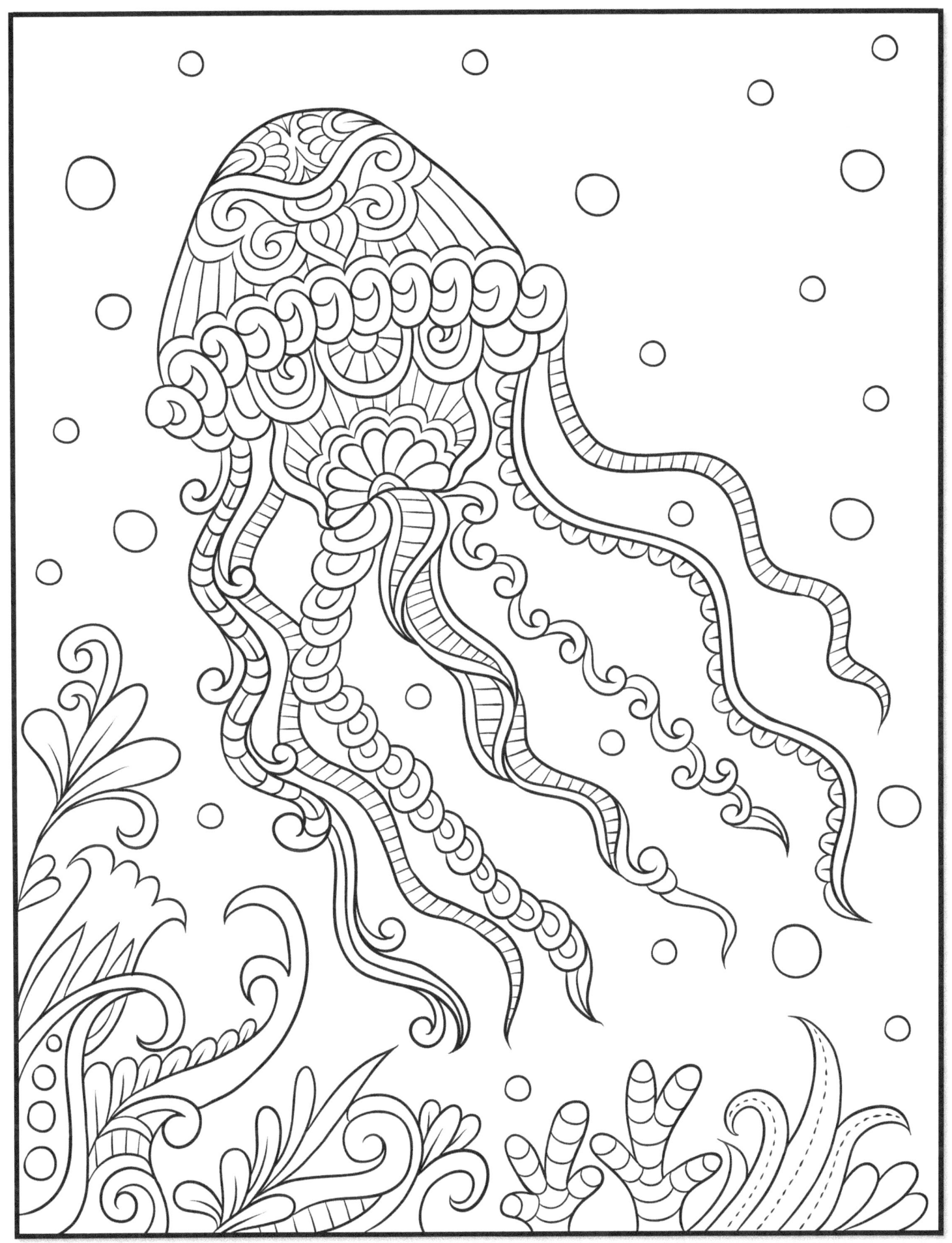

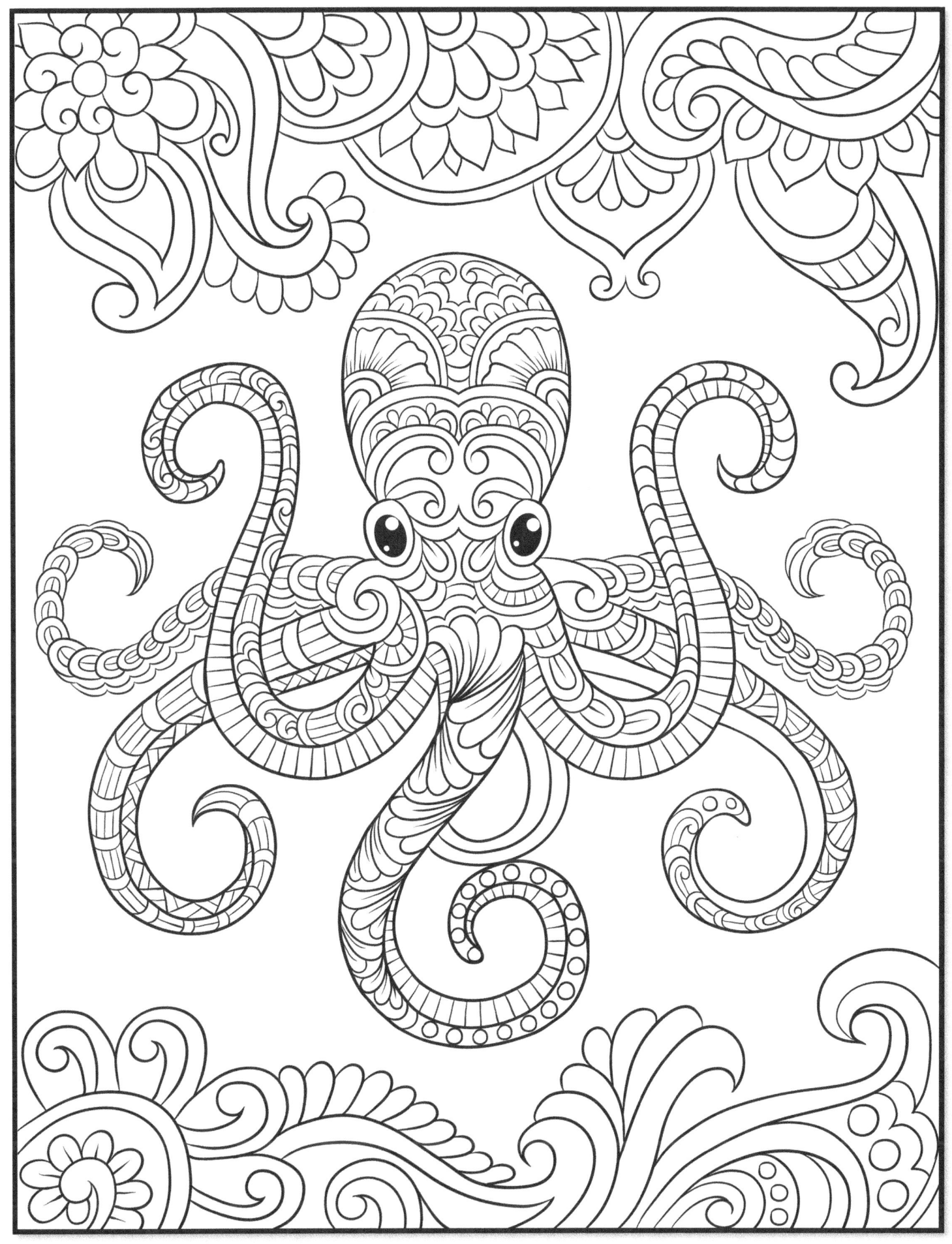

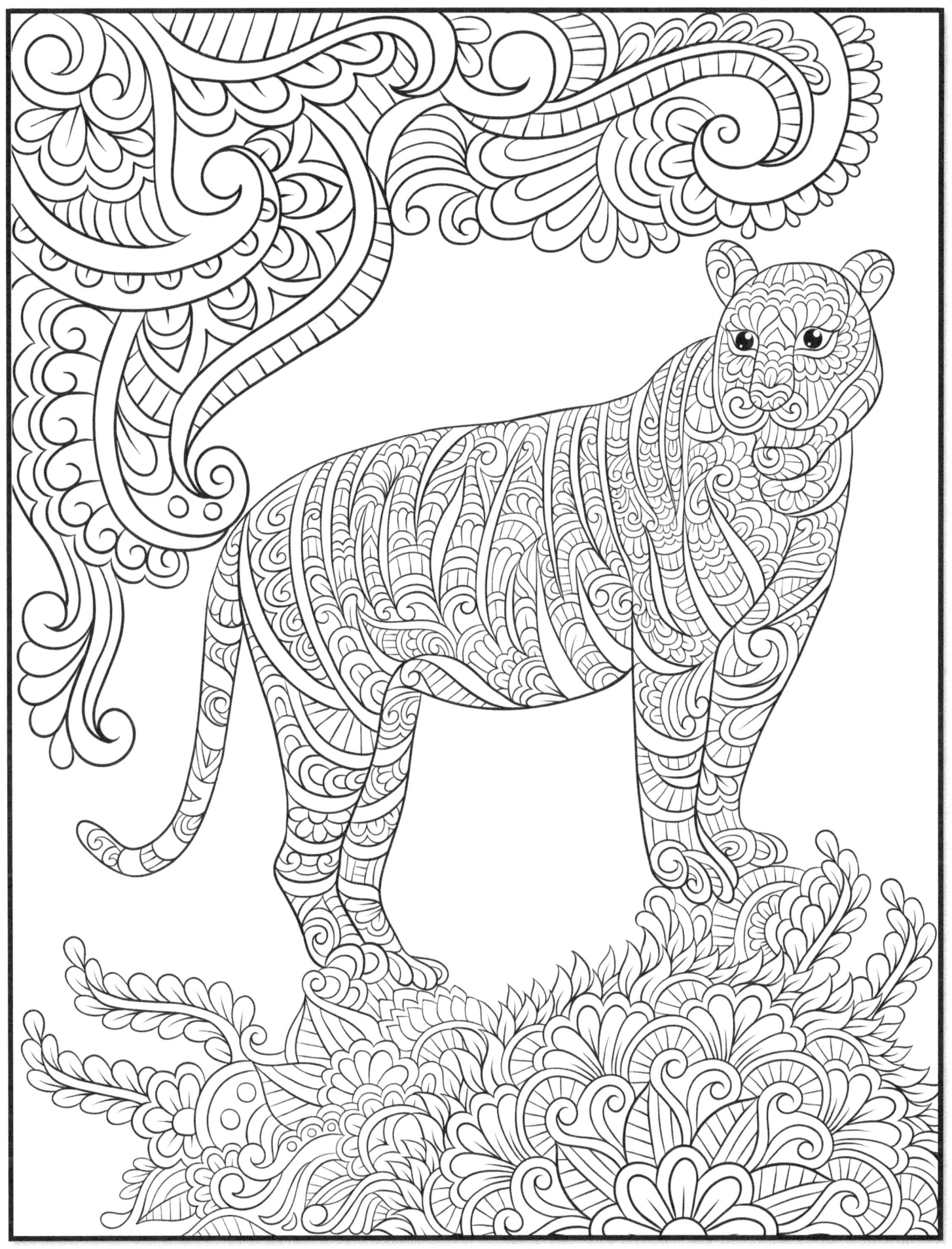

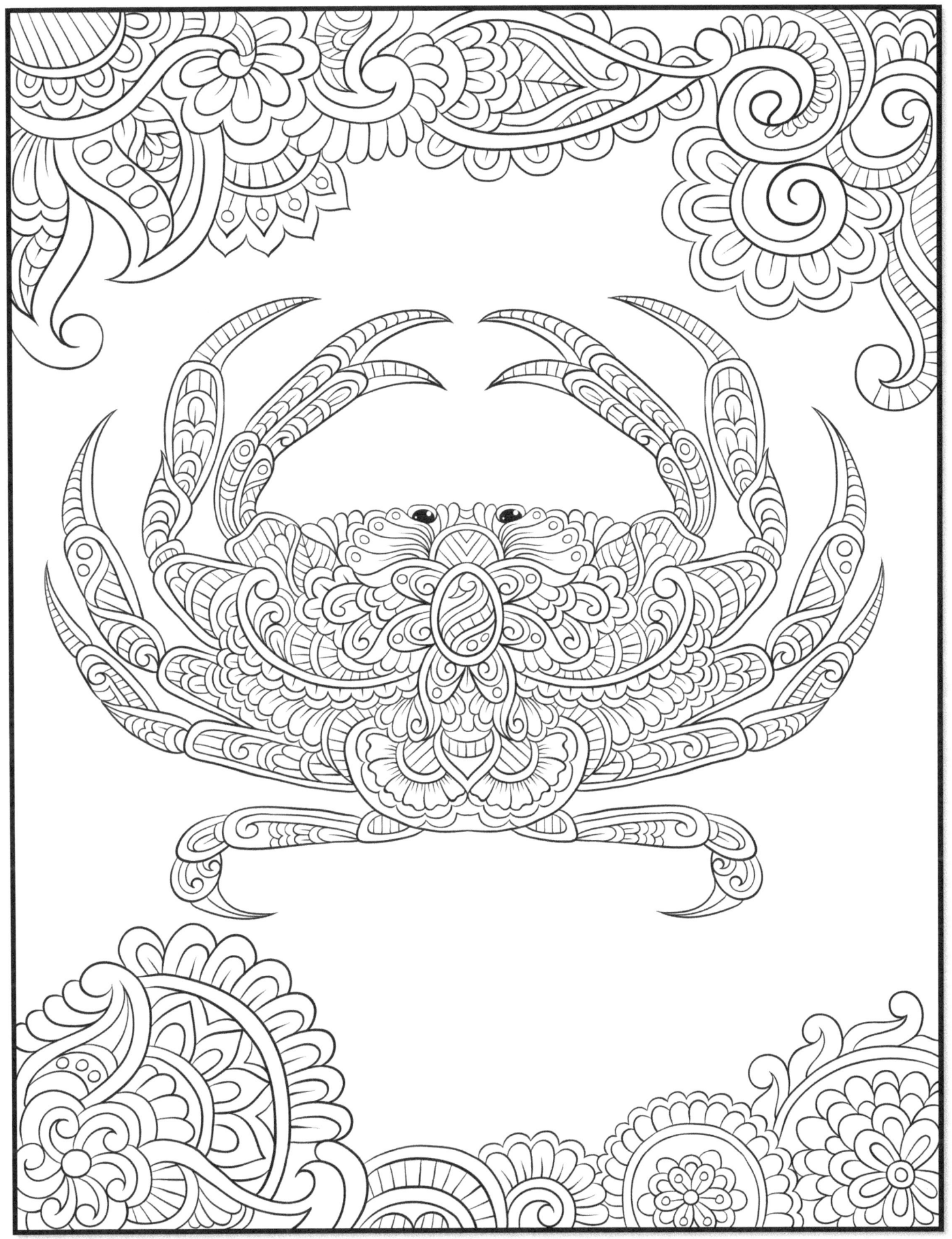

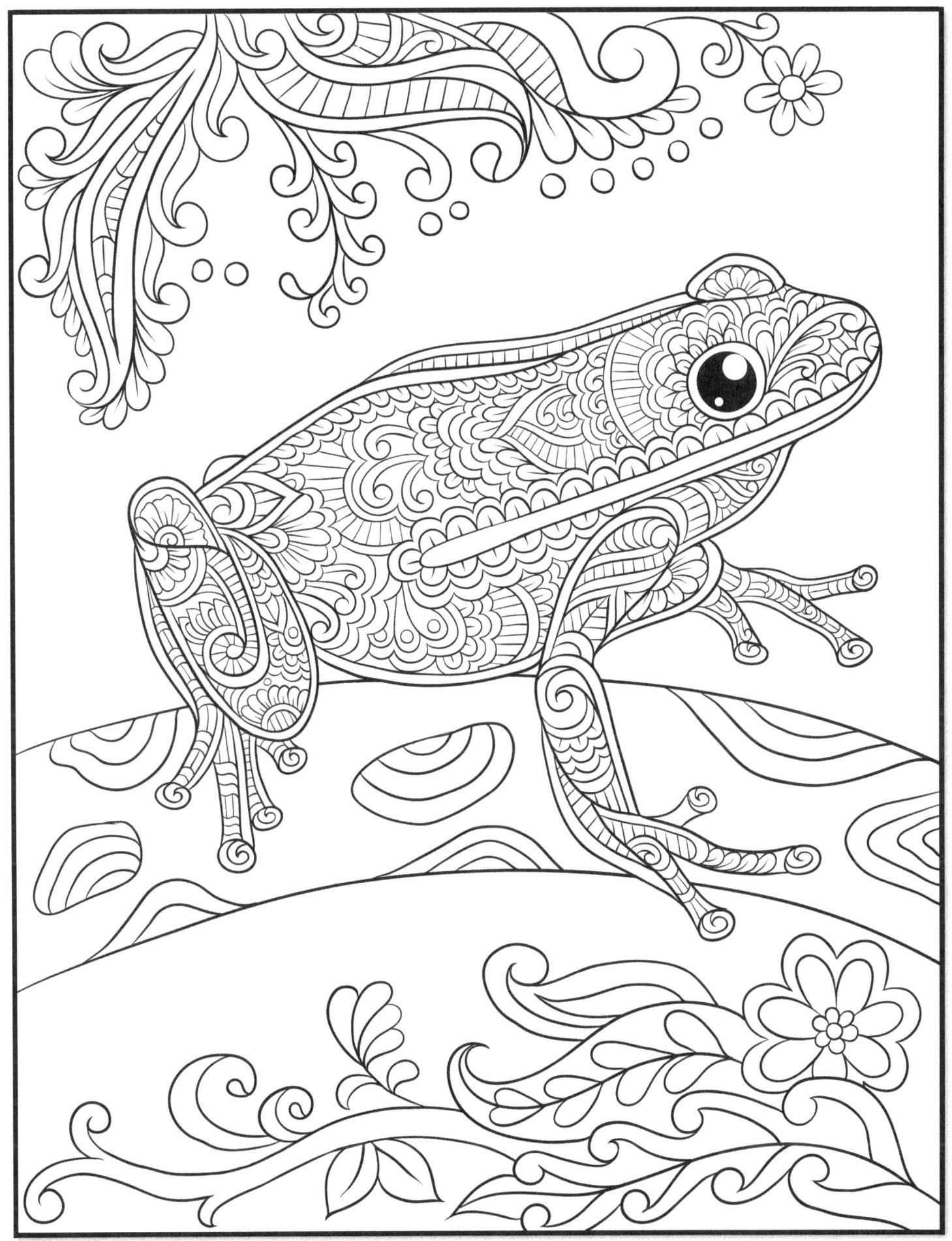

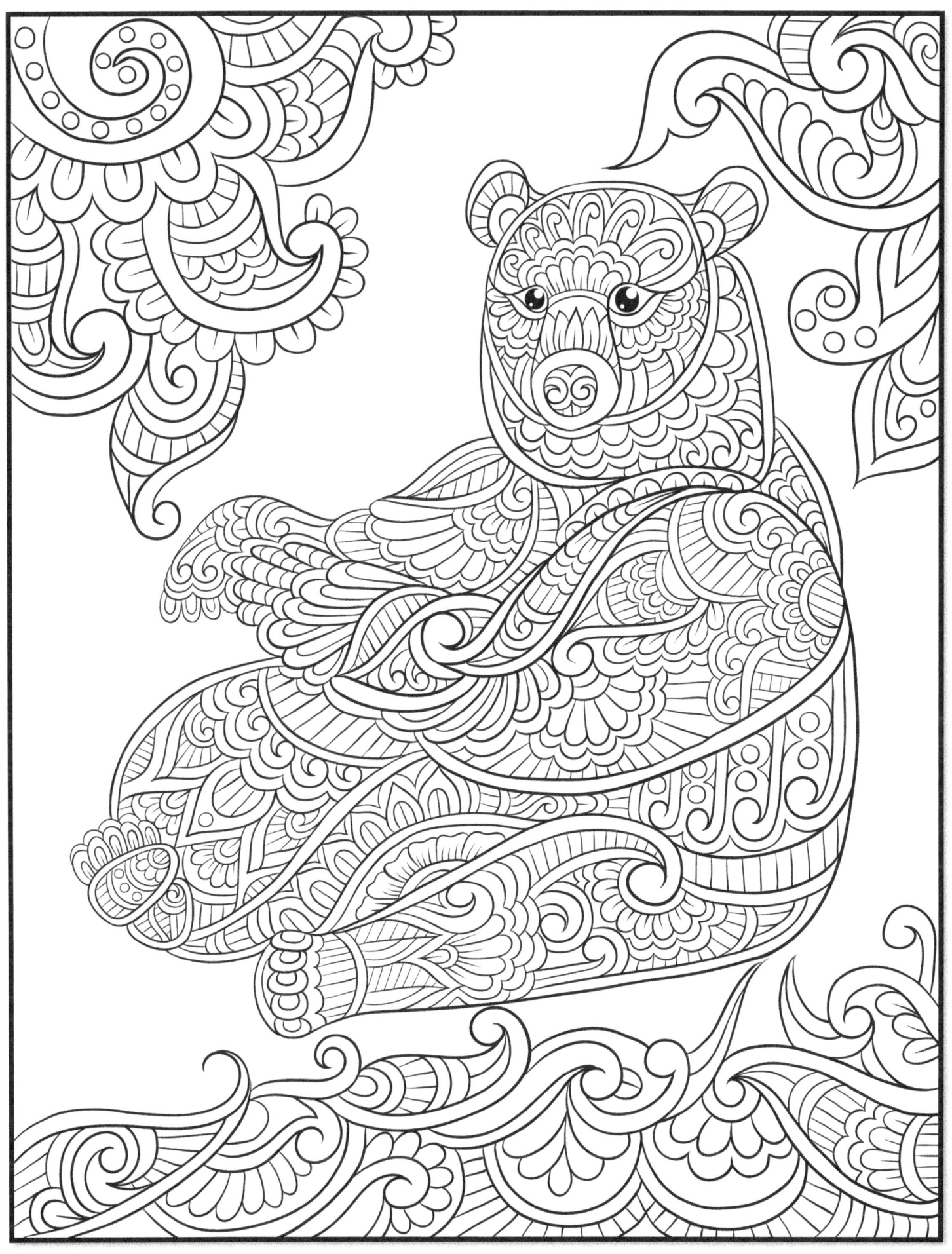

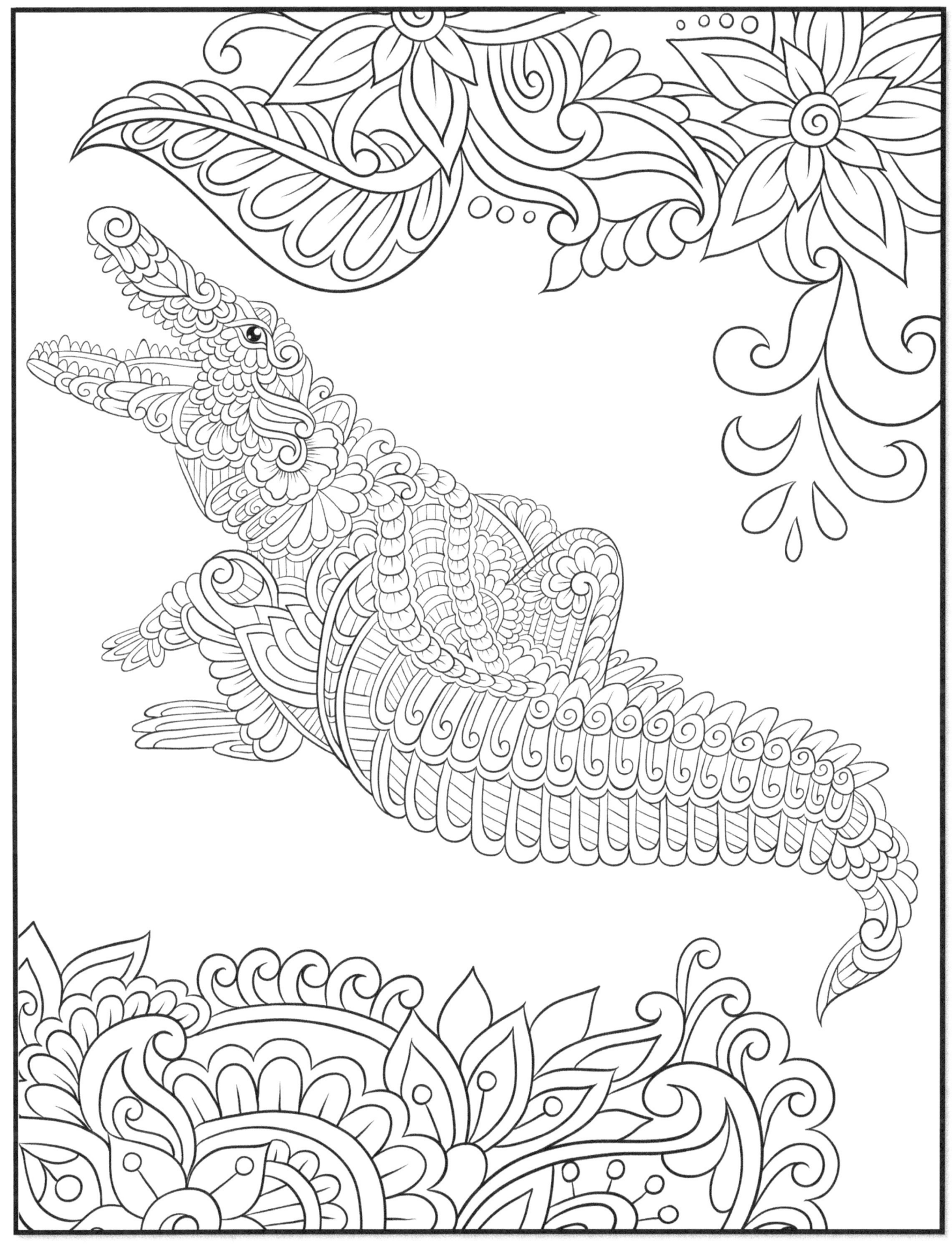

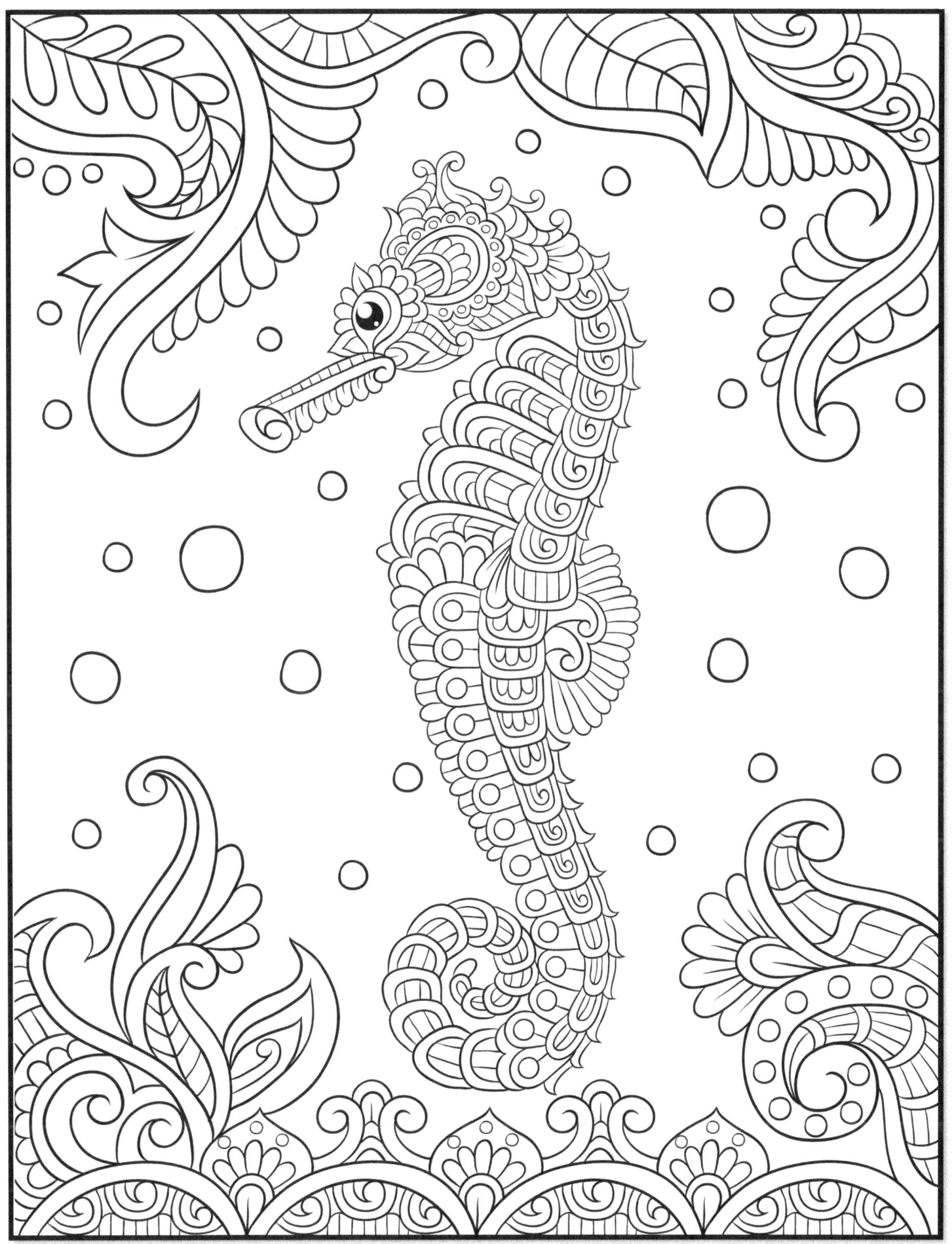

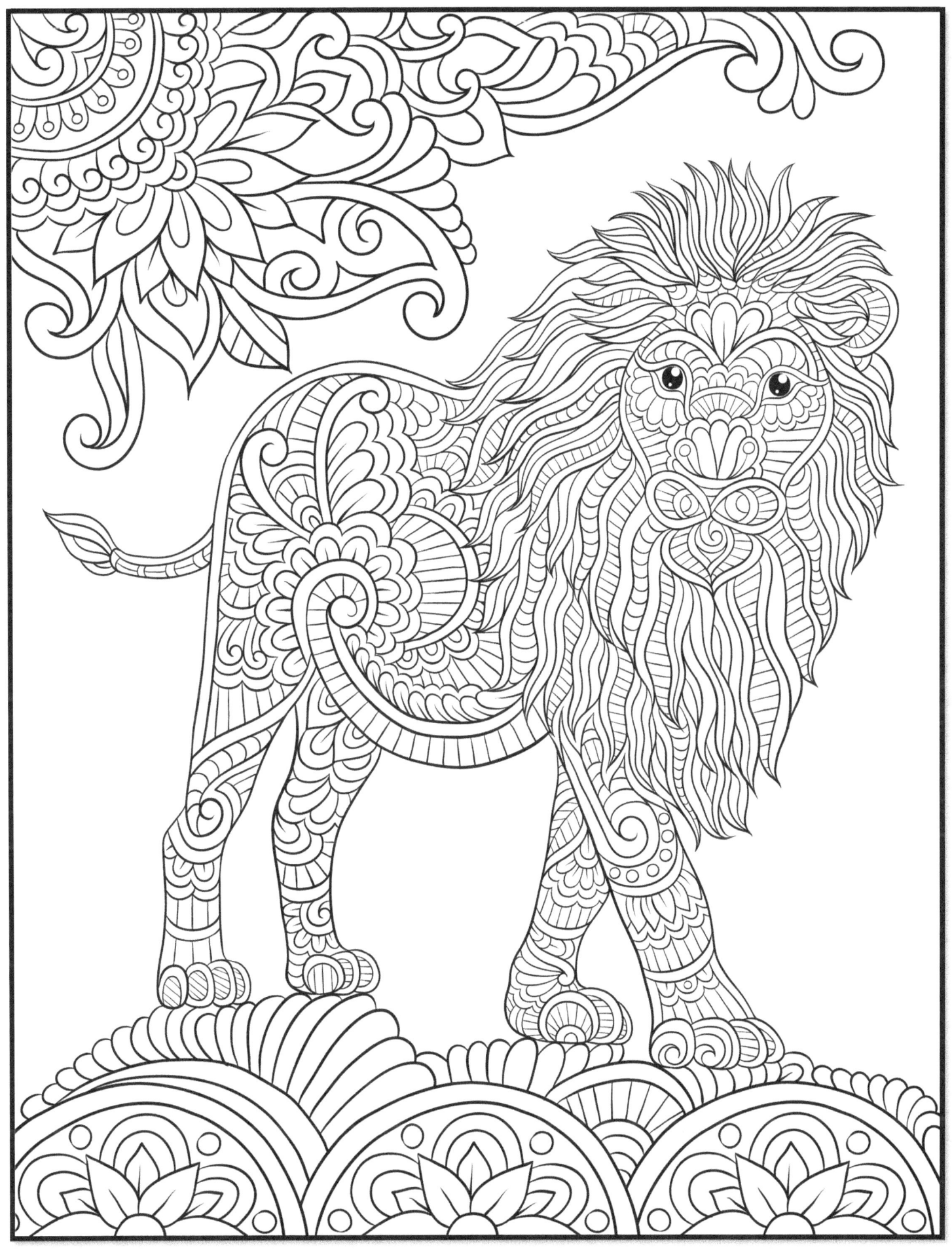

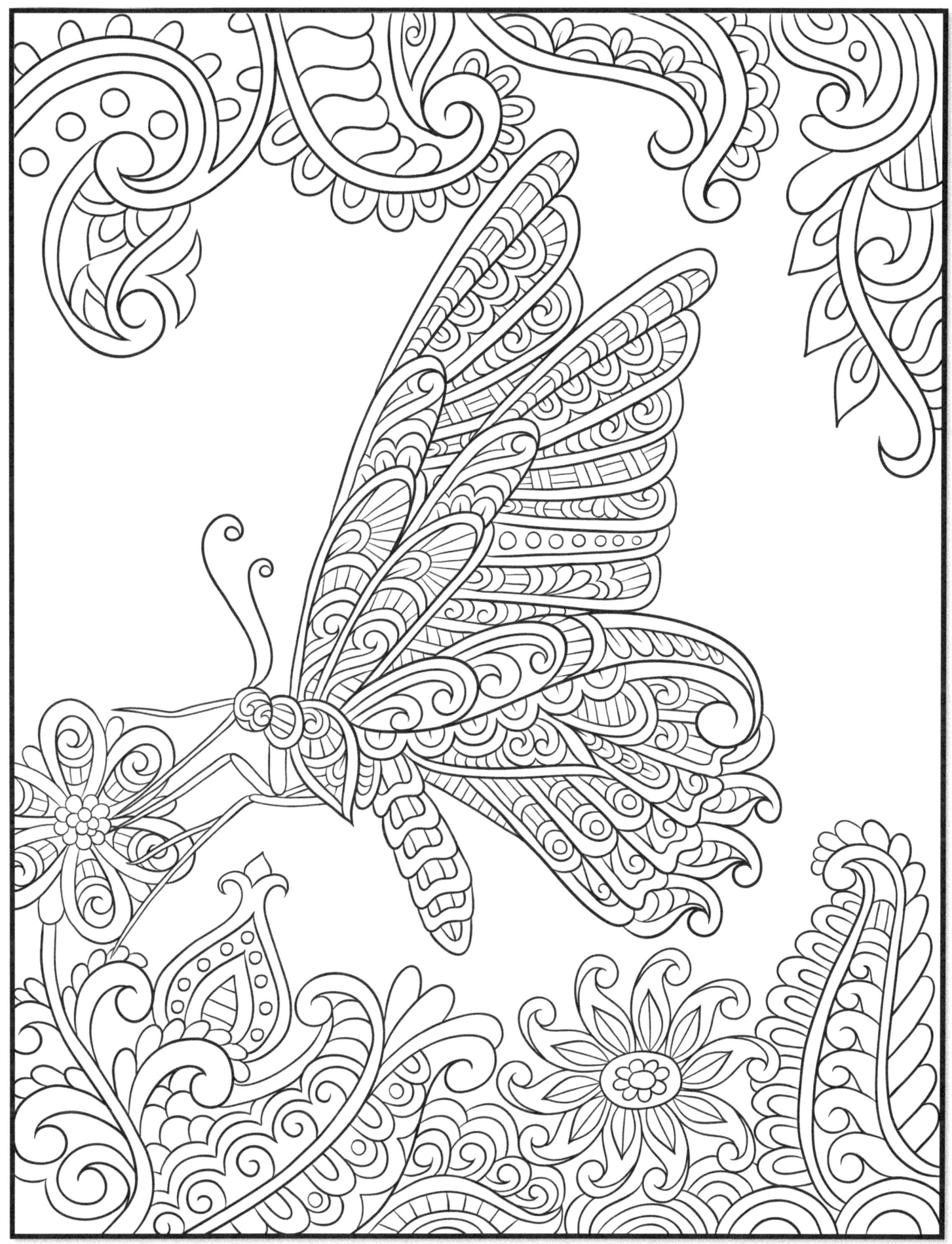

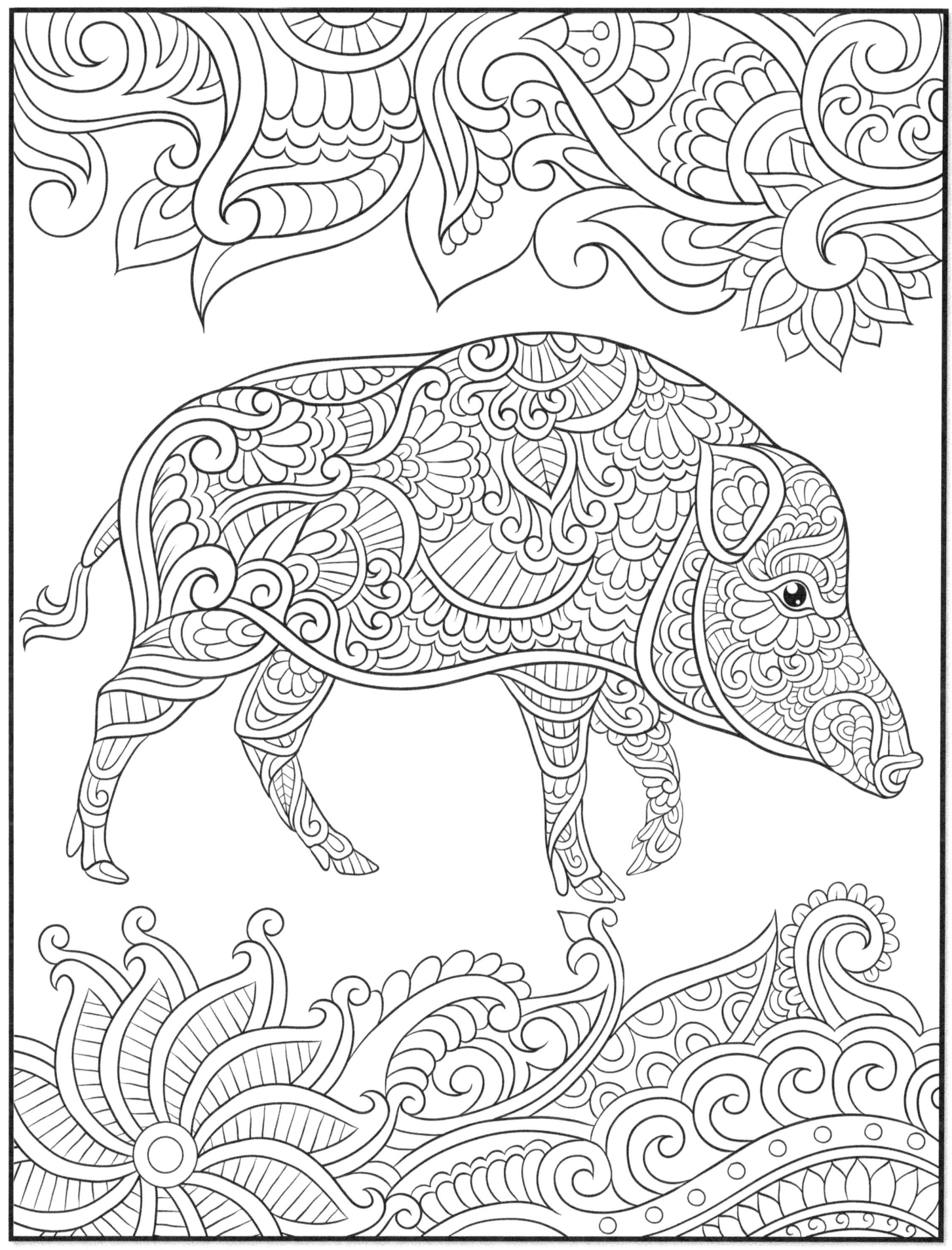

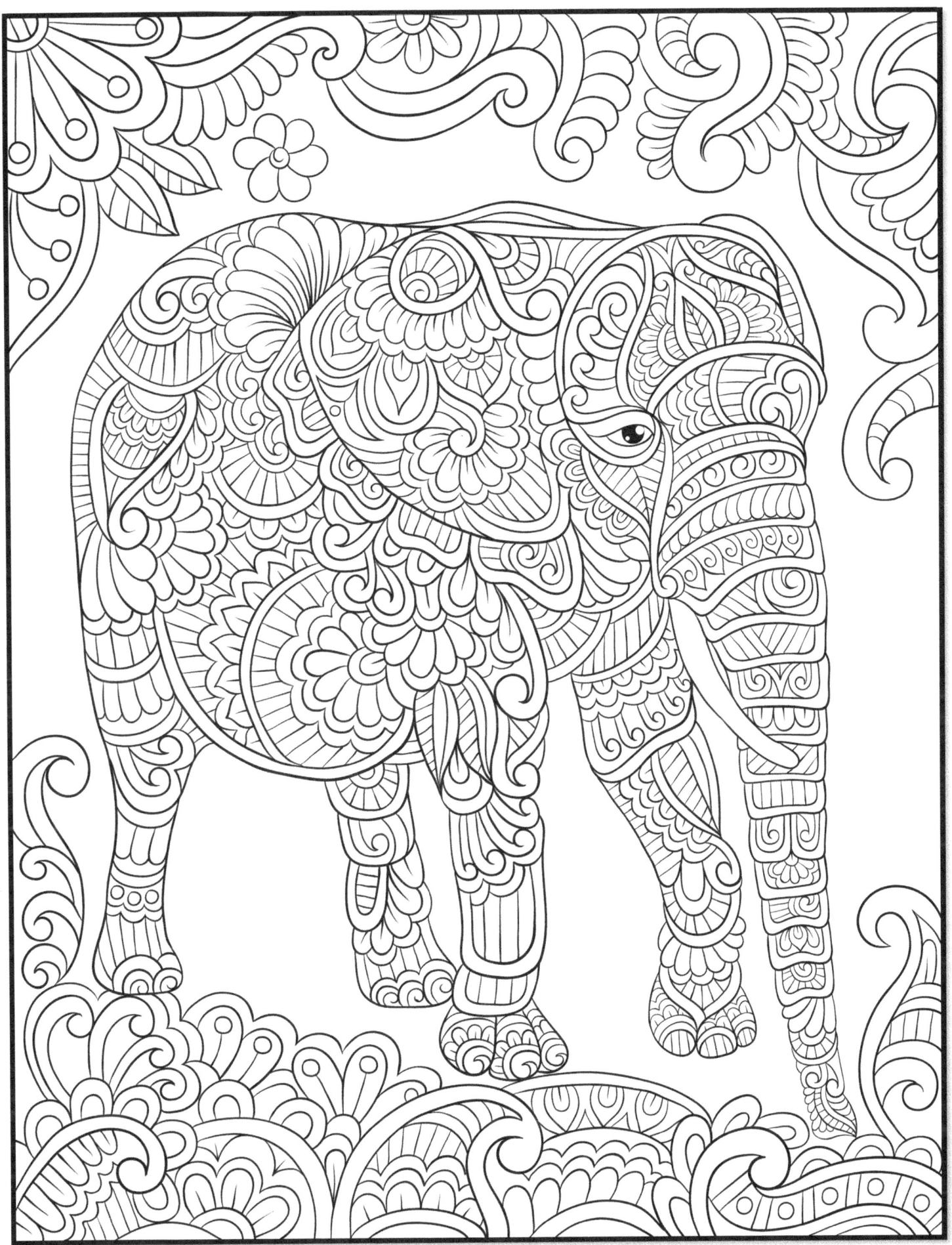

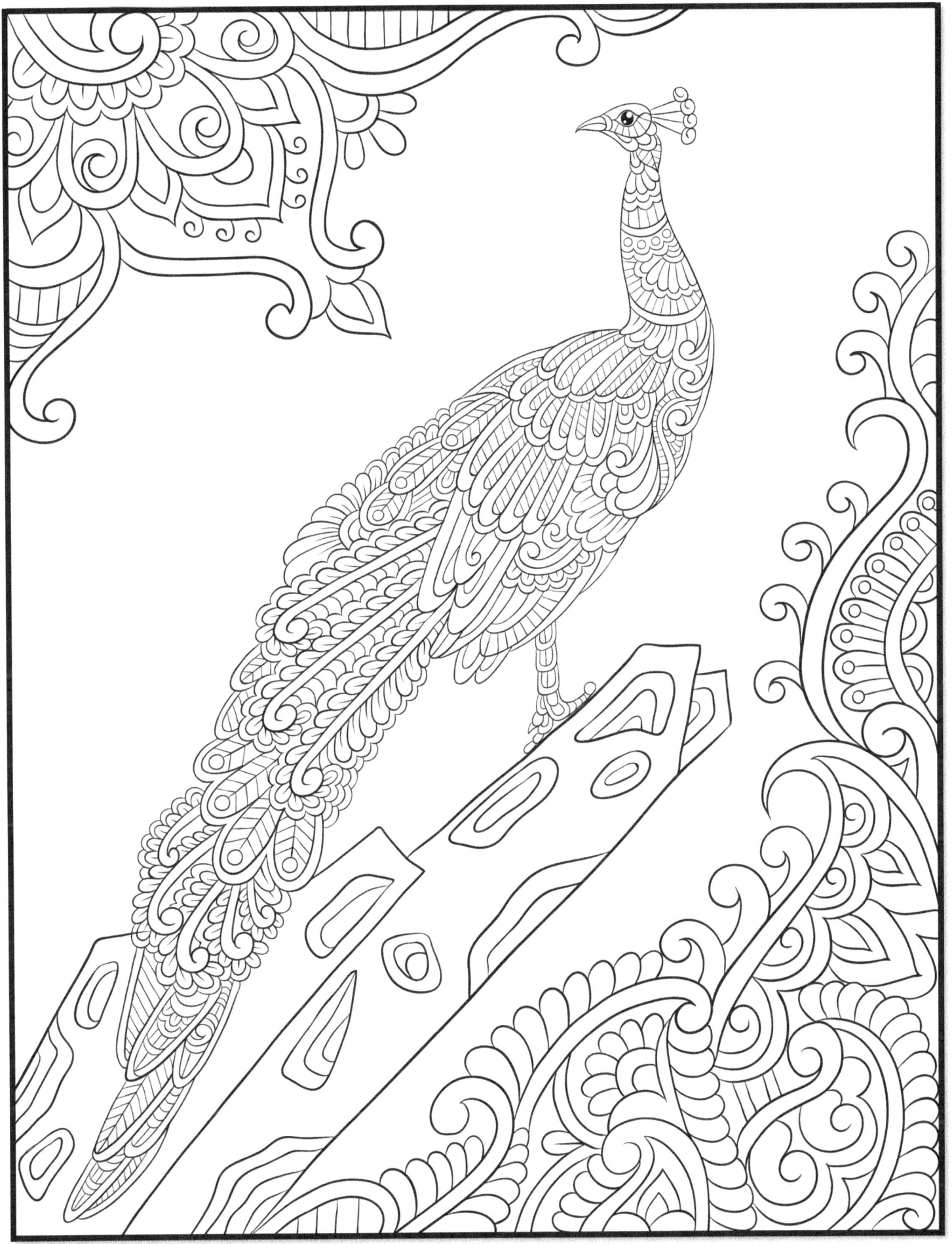

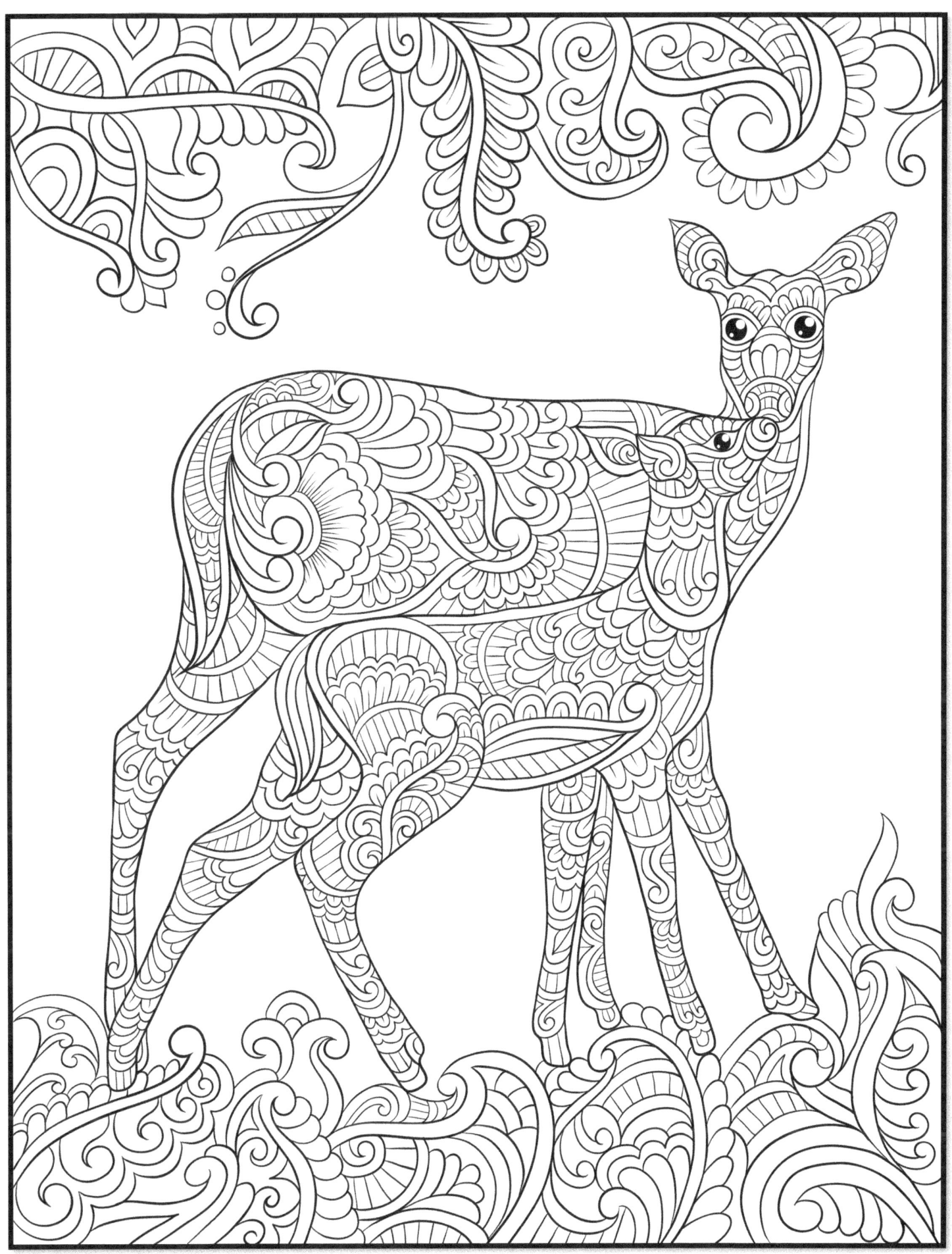

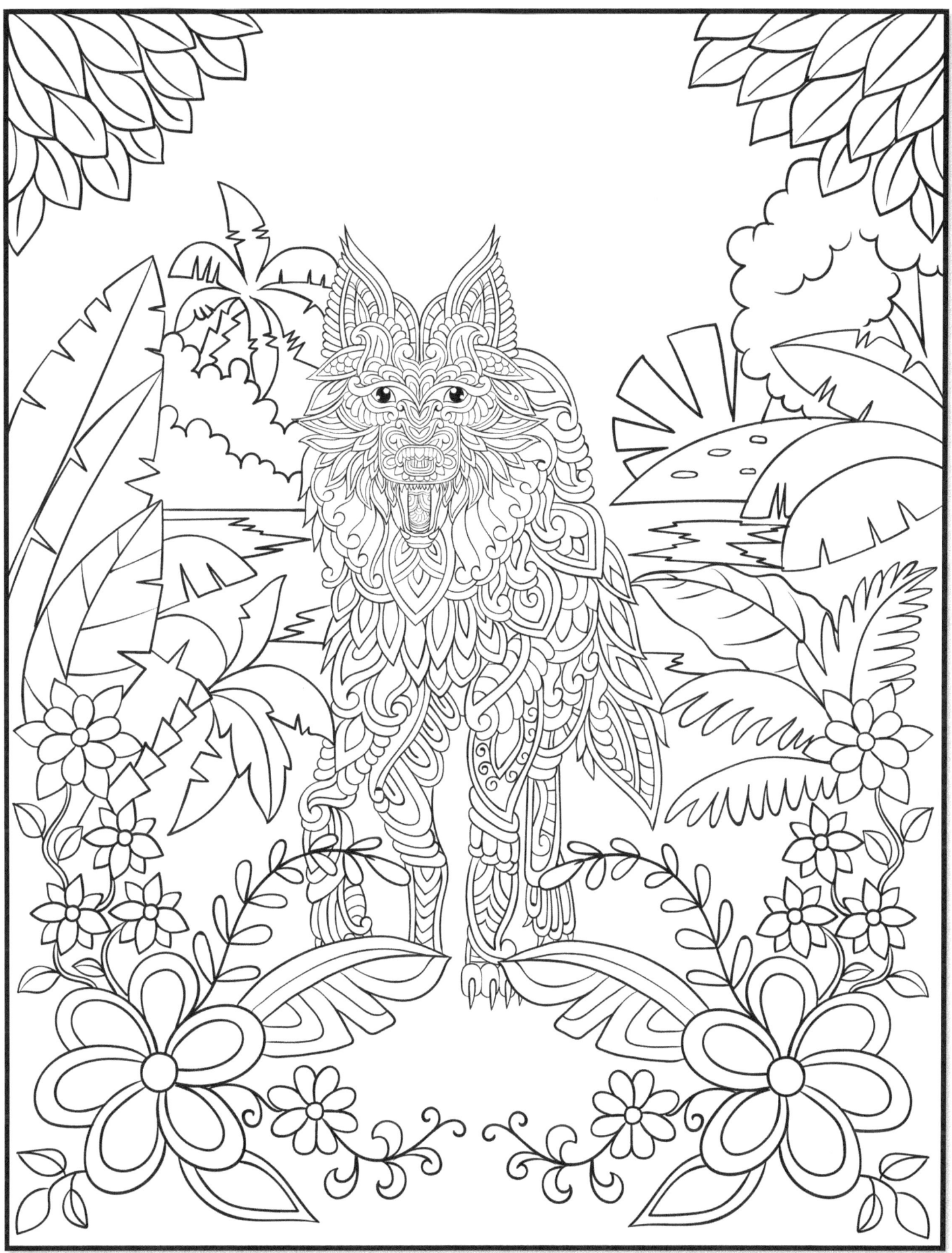

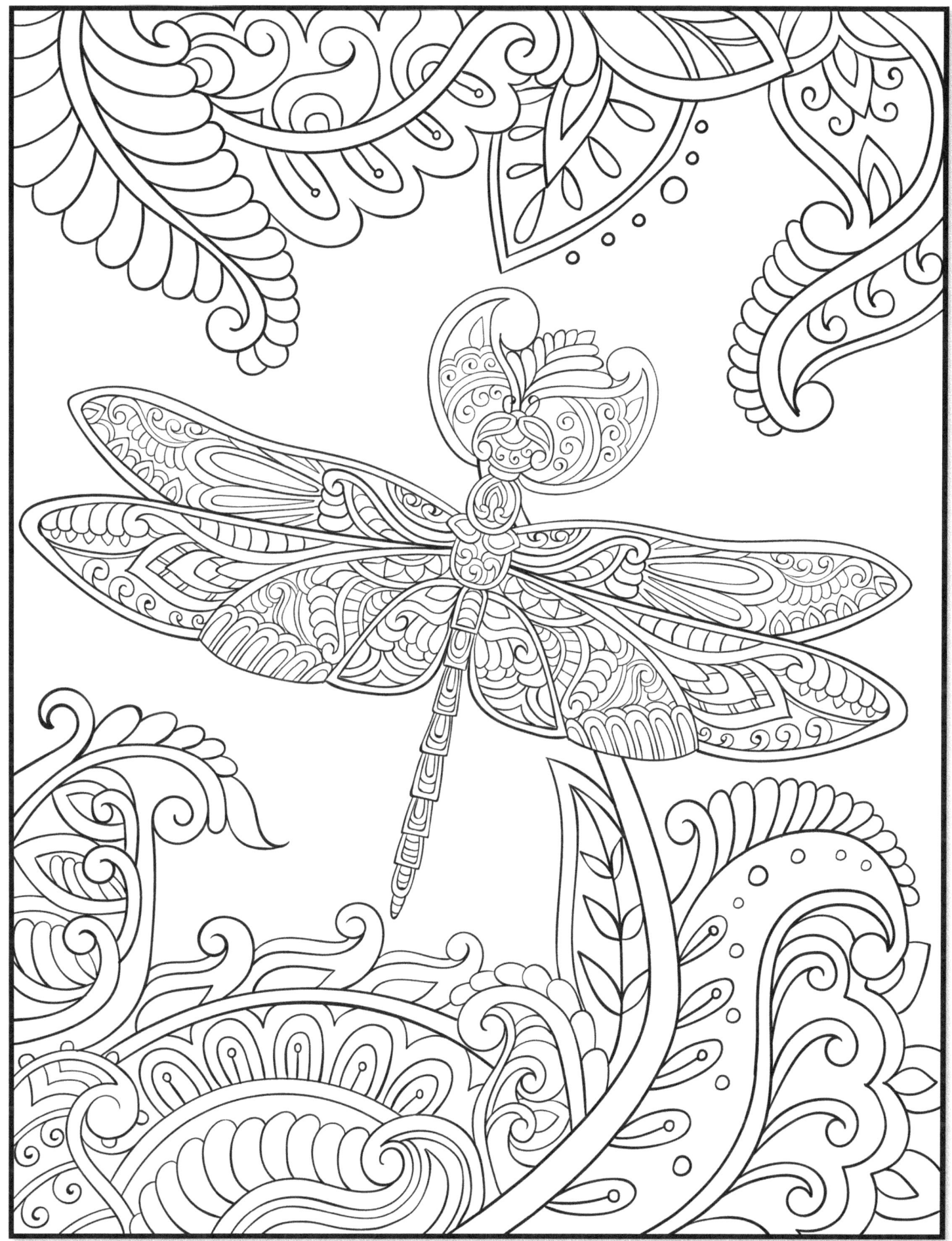

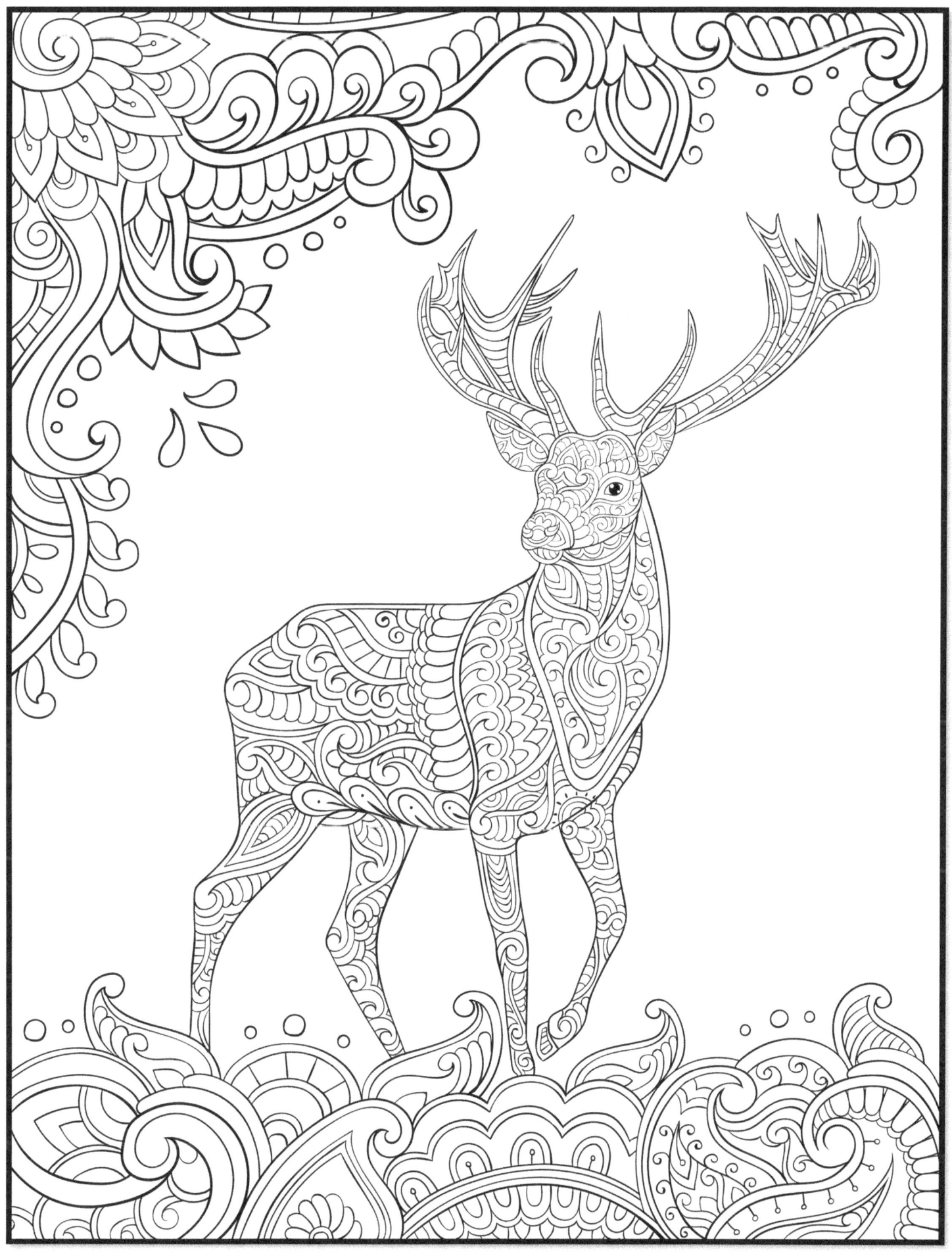

Congratulations!

We hope you enjoyed coloring these pages as much as we enjoyed designing them & that our book provided you hours of relaxing coloring fun.

We are still a young company and can only grow with your help, so every little bit counts. If you like our work and want to see more of it in the future, there are a few things you can do to support us:

Please leave a review for this book by visiting this link: **edencolors.com/review6**

Or by scanning this QR Code:

Interact with us on social media:

Facebook page: **facebook.com/edencolors.com**

Facebook group: **facebook.com/groups/edencolors**

Instagram: **instagram.com/edencolors**

Know other coloring book enthusiasts? Tell them about our books.

Oh and...we'd love to see your work! Send us your colored pages and if you win you can get rewarded with a free coloring book. Learn more on the next page.

Digital Edition Download

Every physical book purchase qualifies for a complimentary free copy of the digital edition.

You can download it here:
edencolors.com/wild-ab6

Please don't share this link anywhere!

Want to win a free coloring book?

We love seeing how people color our illustrations and hold monthly contests for the best colored page.

Simply color a page from this book and submit it to us. By the beginning of next month we choose a winner who will receive one of our coloring books for free!

Get Started: **edencolors.com/contest**

Visit Us Online

EdenColors.com – info@edencolors.com

www.ingramcontent.com/pod-product-compliance
Lightning Source LLC
Chambersburg PA
CBHW080131240526
45468CB00009BA/2355